HOW TO DRAW
DINOSAURS

STEVE BEAUMONT

CHARTWELL
BOOKS, INC.

This edition printed in 2013 by

CHARTWELL BOOKS, INC.
A Division of BOOK SALES, INC.
276 Fifth Avenue Suite 206
New York, New York 10001 USA

Copyright © 2013 Arcturus Publishing Limited
26/27 Bickels Yard, 151–153 Bermondsey Street,
London SE1 3HA

ISBN: 978-0-7858-3019-1
CH000604US
Supplier 03, Date 0413, Print Run 2605

Printed in China

CONTENTS

INTRODUCTION

Dinosaurs… the word conjures up all kinds of powerful and exciting images. From the terrifying jaws of Tyrannosaurus rex to the huge swooping neck of Diplodocus and the horns of Triceratops—dinosaurs came in all shapes and sizes.

These amazing creatures ruled the Earth for over 160 million years until suddenly, they all died out. No one has ever seen a living, moving, roaring dinosaur but thanks to the research of paleontologists, who piece together dinosaur fossils, we now have a pretty good idea what many of them looked like.

Some were as big as huge buildings, others had enormous teeth, scaly skin, horns, claws, and body armor. Dinosaurs have played starring roles in books, on television, and in blockbuster movies and now it's time for them to take center stage on your drawing pad!

In this book we've chosen 18 incredible dinosaurs for you to learn how to draw. There are mighty meat eaters, placid plant eaters, armored dinosaurs, record-breaking giant dinosaurs and creatures from the sea and sky. We've also included three dinosaur landscapes for you to draw, so you can really set the prehistoric scene.

You'll find advice on the essential drawing tools you'll need to get started, tips on how to get the best results from your drawings, and easy-to-follow step-by-step instructions showing you how to draw each dinosaur. So, it's time to bring these extinct monsters back to life—let's draw some dinosaurs!

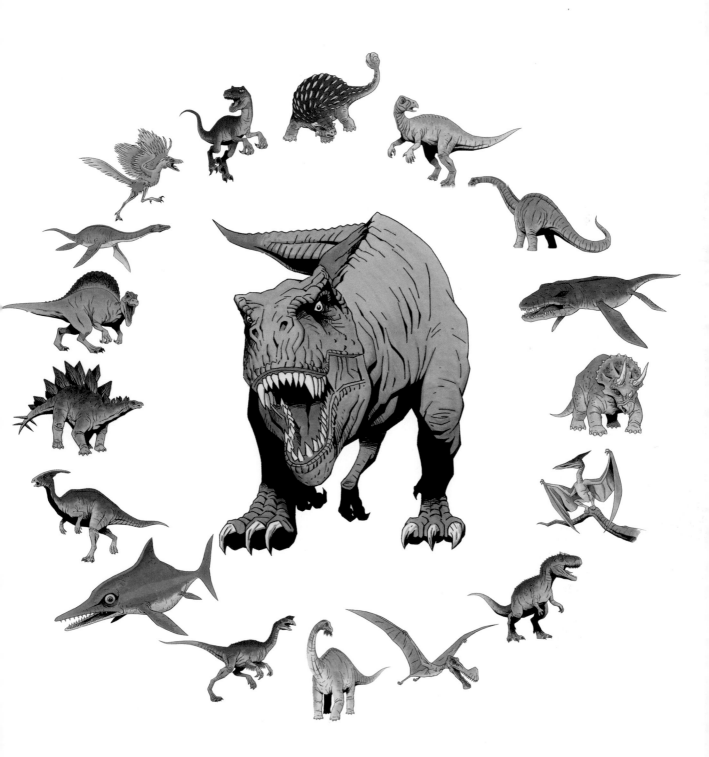

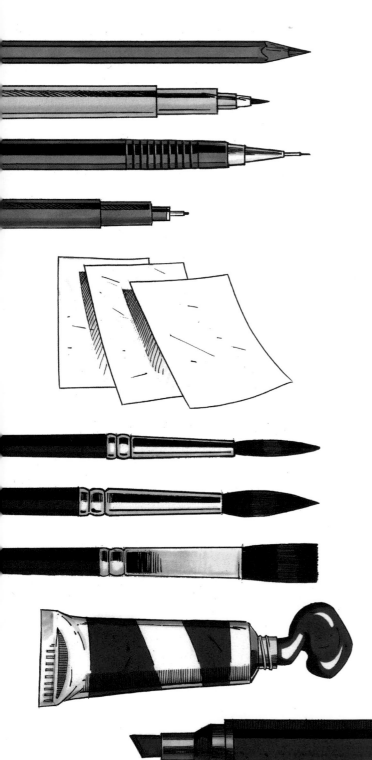

DRAWING TOOLS

Let's start with the essential drawing tools you'll need to create awesome illustrations. Build up your collection as your drawing skills improve.

LAYOUT PAPER

Artists, both as professionals and as students, rarely produce their first practice sketches on their best quality art paper. It's a good idea to buy some inexpensive plain letter or size C paper (whichever you prefer) from a stationery store for all of your practice sketches. Go for the least expensive kind.

Most professional illustrators use cheaper paper for basic layouts and practice sketches before they get round to the more serious task of producing a masterpiece on more costly material.

CARTRIDGE PAPER

This is heavy-duty, quality drawing paper, ideal for your final version. You don't have to buy the most expensive brand, most decent art or craft shops will stock their own brand or a student range and unless you're thinking of turning professional, these will do fine.

WATERCOLOR PAPER

This paper is made from 100 percent cotton, and is much higher quality than wood-based papers. Most art shops will stock a large range of weights and sizes. 250 g/m or 300 g/m will be fine.

LINE ART PAPER

If you want to practise black and white ink drawing, line art paper enables you to produce a nice clear crisp line. You'll get better results than you would on cartridge paper as it has a much smoother surface.

PENCILS

It's best not to cut corners on quality here. Get a good range of graphite (lead) pencils ranging from soft (6B) to hard (2H).

Hard lead lasts longer and leaves less graphite on the paper. Soft lead leaves more lead on the paper and wears down more quickly. Every artist has their personal preference, but 2H pencils are a good medium range to start out with until you find your own favorite.

Spend some time drawing with each weight of pencil and get used to their different qualities. Another good product to try is the clutch, or mechanical pencil. These are available in a range of lead thicknesses, 0.5mm being a good medium range. These pencils are very good for fine detail work.

PENS

There are a large range of good quality pens on the market these days and all will do a decent job of inking. It's important to experiment with a range of different pens to determine which you find most comfortable to work with.

You may find that you end up using a combination of pens to produce your finished piece of artwork. Remember to use a pen that has watertight ink if you want to color your illustration with a watercolor or ink wash.

It's quite a good idea to use one of these anyway, there's nothing worse than having your nicely inked drawing ruined by an accidental drop of water!

BRUSHES

Some artists like to use a fine brush for inking linework. This takes a bit more practice and patience to master, but the results can be very satisfying. If you want to try your hand at brushwork, you will definitely need to get hold of some good quality sable brushes.

ERASER

There are three main types of eraser: rubber, plastic, and putty. Try all three to see which kind you prefer.

PANTONE MARKERS

These are very versatile pens and with practice can give pleasing results.

INKS

With the dawn of computers and digital illustration, materials such as inks have become a bit obscure, so you may have to look harder for these but most good art and craft shops should stock them.

WATERCOLORS AND GOUACHE

Most art stores will stock a wide range of these products from professional to student quality.

CIRCLE TEMPLATE

This is very useful for drawing small cirles.

FRENCH CURVES

These are available in a few shapes and sizes and are useful for drawing curves.

BASIC SHAPES

You may be surprised to learn that a dinosaur can be constructed using a handful of basic shapes. All the dinosaurs in this book can be broken down into cylinders, spheres, cubes, oblongs, and the egg shape, which is very similar to the oval but narrower at one end. Learning how to give 3-dimensional form to simple shapes is the secret to drawing lifelike dinosaurs.

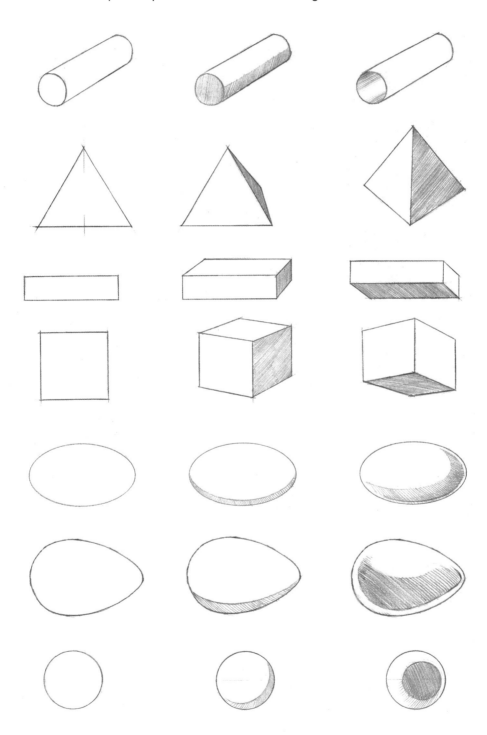

BUILDING DINOSAURS

Notice how a simple oval shape forms the body of these three dinosaurs (figs.1, 2, and 3). Even though they are all very differently shaped, an oval forms the body of each one perfectly.

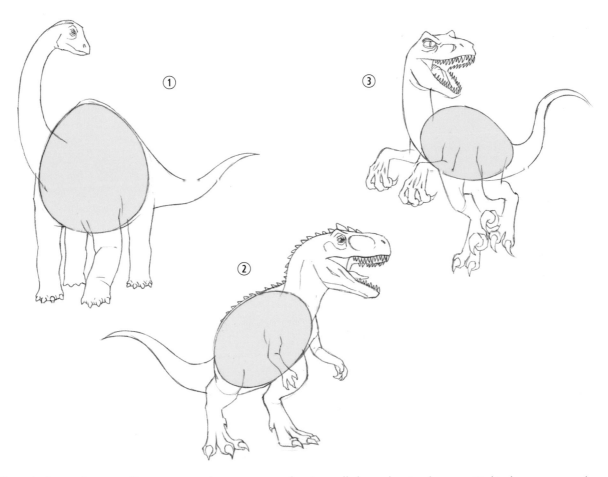

Fig. 4 shows how a dinosaur can be construced using all these basic shapes. Cylinders are used for its legs and arms, an oval shape forms its body, and a smaller egg shape is used for its head.

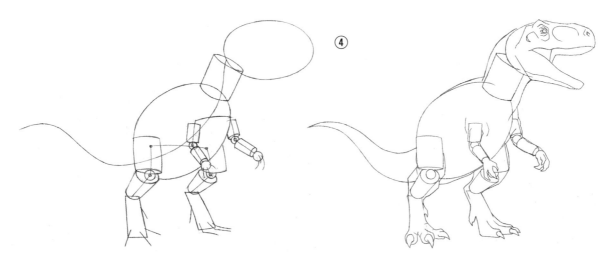

9

DRAWING DINOSAUR HEADS

The egg shape (fig. 1) can be used as a base to start the heads of most dinosaurs (fig. 2). When it comes to drawing flying reptiles, such as the Pteranadon, an egg shape can still be used with the addition of triangles to form the beak (fig. 3).

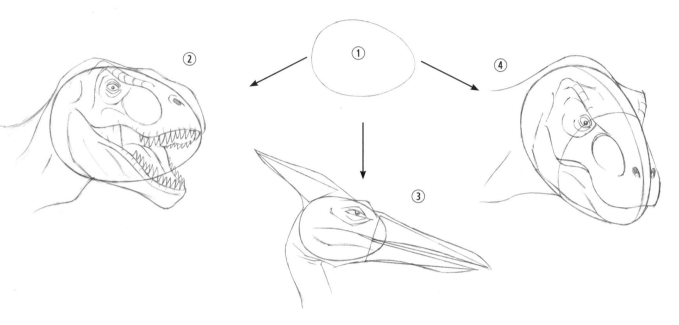

A useful tip when drawing the head of a dinosaur is to divide it up (fig. 4). Start with a central line down the middle and add a horizontal line about a third of the way down to plot where the eyes will sit. This may take a bit of practice but the more you draw the easier it will become.

CONSTRUCTING A TRICERATOPS HEAD

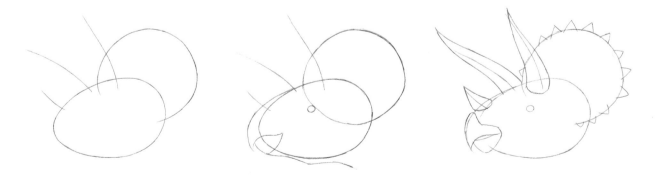

See how the egg shape forms the Triceratops' head, with a circle for its crest. Extend out from the egg shape to draw its beak-like mouth and draw three lines to show where the horns will go. By building on these basic shapes, your dinosaurs will come to life! See pages 79–84 to learn how to draw the whole Triceratops.

DRAWING THE EYES AND TEETH

Simple circles are all you need to start the eyes (figs. 1 and 2). The appearance of the eye on the face is determined by the construction of the lids (figs. 3 and 4) and the surrounding skin (fig. 5).

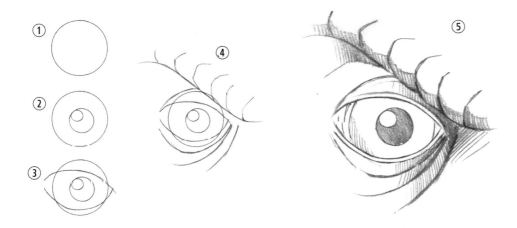

Below is how to draw the eye of a Velociraptor. Notice that the pupil is similar to that of a cat.

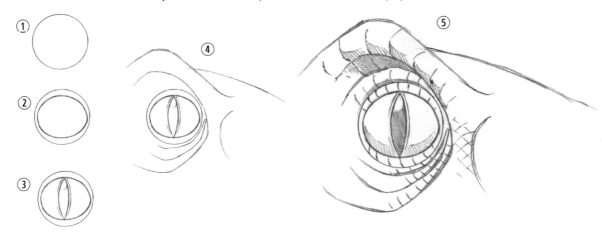

When drawing the teeth try not to opt for the lazy option of drawing zigzags (fig. 1) but try to think of how animal teeth really look. They come in all shapes and sizes. By taking a bit more time and effort with the teeth you can give your drawing a more realistic appearance (figs. 2 and 3).

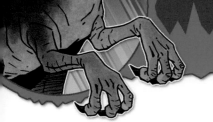

DRAWING CLAWS

Dinosaurs come in all shapes and sizes and so do their hands and feet. See the two columns below. On the left we have a Velociraptor's long thin digits, and on the right, a T-rex's stumpy claw. Although they look very different, both can be constructed using the same basic shapes.

VELOCIRAPTOR CLAW　　　　　　　　　　　　　　　**T-REX CLAW**

STEP 1

Draw a circle for the palm, a cylinder for the lower arm, and lines for the fingers. Use little circles to mark where the finger joints will go.

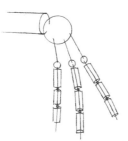

STEP 2

Use cylinder shapes to construct the thickness of the fingers. Velociraptor's are thin (see left) and T-rex's are fat (see right).

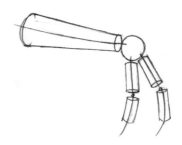

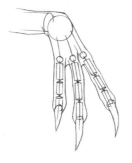

STEP 3

Now draw around the shapes to form the skin and add the claws.

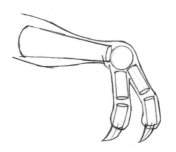

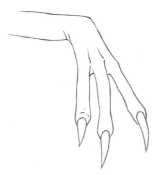

STEP 4

Finish off by erasing your construction shapes and adding some detail. Start to give a fleshy, textured appearance to the skin.

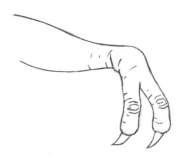

DRAWING FEET

Dinosaurs like T-rex and Velociraptor have feet that resemble the structure of a large bird, but the feet of bulkier dinosaurs such as Diplodocus and Triceratops look very different. See the columns below to learn how to construct T-rex and Diplodocus feet.

T-REX FOOT **DIPLODOCUS FOOT**

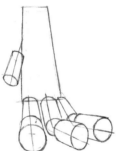

STEP 1

First draw your basic shapes. T-rex (left) is mainly constructed using a rectangle, with lines for the toes. For the flatter Diplodocus foot (right), use a semicircle and a cylinder.

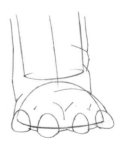

STEP 2

Use two cylinders for each of T-rex's toes. The little toe that sits higher up on the foot only needs one. With Diplodocus' feet, add circular shapes to form the toenails.

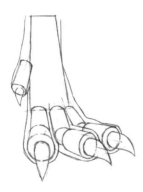

STEP 3

Now flesh out the feet adding skin and claws.

STEP 4

Erase all of your construction shapes. Add detail to the skin and finally some shading to bring depth to the drawing. There you have it—two very different dinosaur feet!

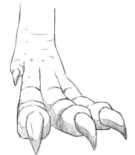

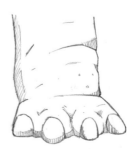

INKING

Once you have completed your dinosaur in pencil, it's time to start inking over the lines for a really dramatic effect. Although you could faithfully follow the pencil drawing, try to vary the thickness of your ink lines for a more interesting and powerful result. Try practicing with different pens and inks.

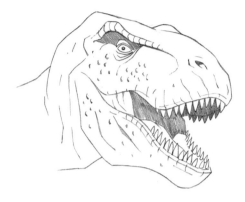

STEP 1
Here we have a pencil drawing of T-rex.

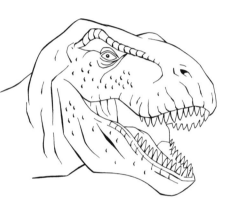

STEP 2
Follow the pencil line and start inking. Using thicker lines for the folds of skin, wrinkles, and crevices will add depth.

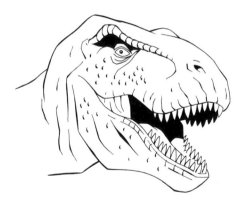

STEP 3
Now apply solid black around the eye and inside the mouth.

STEP 4
By adding some simple hatching around the eye area it creates extra interest. Attention to detail like this will make your dinosaur look even more realistic.

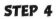

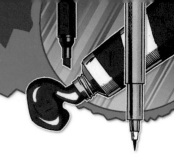

COLORING

After inking comes the final coloring stage. In this section we are going to go through the stages of coloring a Stegosaurus. The methods described are suitable for watercolors or colored marker pens. You could also experiment with colored pencils to achieve a similar effect.

STEP 1

Start by applying the base color. For Stegosaurus, a light sand color has been used. Notice how the color isn't completely flat and has texture to it. This can be achieved in the following ways: if you are using watercolors, try not to lay the color down too flatly or allow it to dry unevenly, looking slightly patchy. If you are using colored markers, wait until the first layer of ink has dried and then go over it using a blender marker. This will disperse the pigment in the ink for a textured effect.

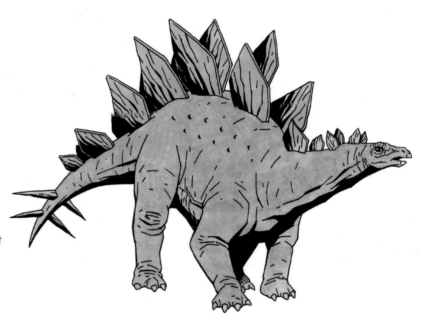

STEP 2

Now apply light green to the back, neck, tail, and down the sides of the legs. If you're using watercolors, go over the top of the base color keeping your strokes patchy and light. A good trick if you are using colored markers, is to apply ink onto a swab of cotton wool or tissue paper and quickly dab the swab onto the paper. This will create a nice uneven skin texture.

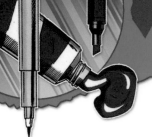

STEP 3
Now apply a light gray wash to the overall image to dull the colors.

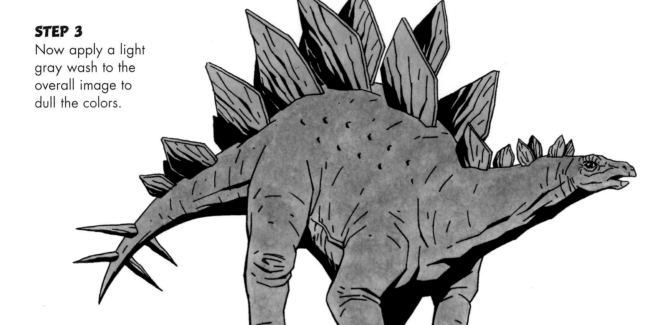

STEP 4
Add olive green to finish off the skin. Start to color the armored plates on its back in a yellow-orange color.

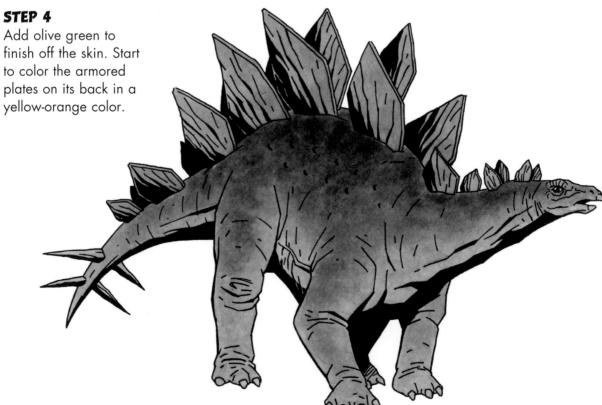

STEP 5

Using a darker orange of a similar tone, add shading to the darker areas of the armored plates.

STEP 6

Finally apply some mid-gray to the skin where the folds and creases are, and to the spikes protruding from its tail.

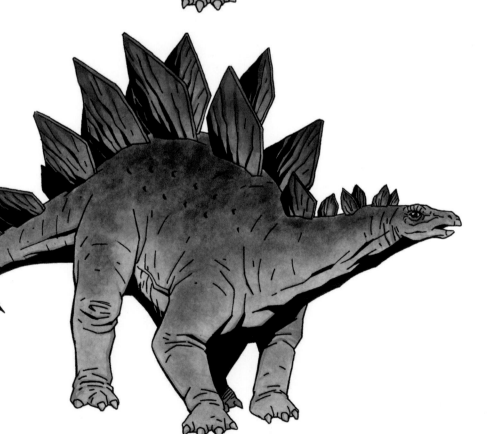

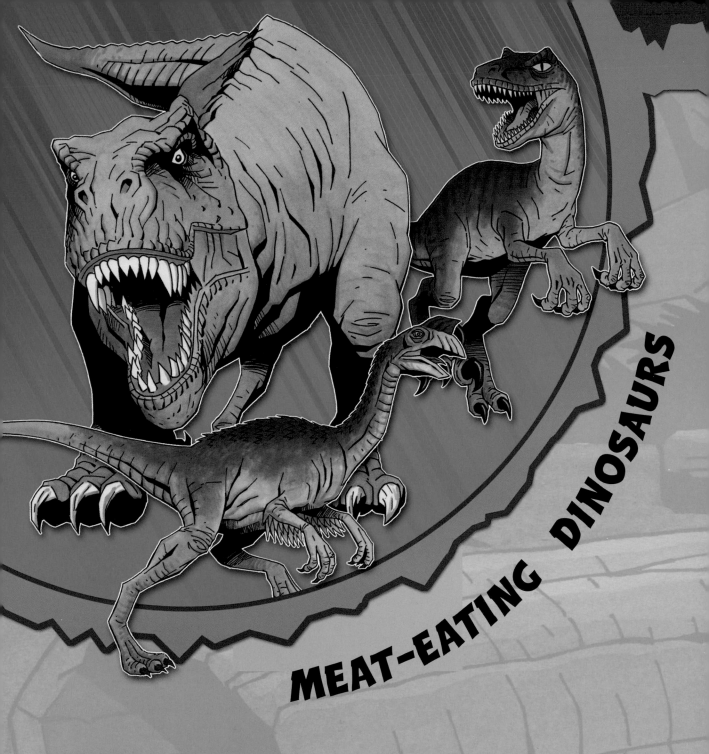

MEAT-EATING DINOSAURS

When you imagine a terrifying dinosaur it's likely that one of the mighty meat eaters will come to mind.

It's estimated that 35 percent of dinosaurs were carnivores and relied on regular meat to survive. These dinosaurs were fast-moving hunters with sharp teeth for tearing flesh and crushing bones. They often had the ability to regrow teeth if they fell out.

Their powerful jaws were strong enough to tackle armored dinosaurs, even with their protective plates—we know for certain that T-rex liked to munch on Triceratops.

They got hold of their meat in any way they could, by hunting prey, scavenging for dead carcasses, or snacking on bite-sized creatures such as lizards or mammals, while others stole eggs to survive. Get ready to draw three of the best.

TYRANNOSAURUS REX

DINO FACT FILE

The superstar of the dinosaur world, Tyrannosaurus rex (meaning "tyrant lizard king") was a huge meat eater that lived about 65 million years ago. Its head was as big as a refrigerator, and it boasted about 50 teeth, each one longer than a human hand. Its massive skull was balanced by a long, heavy tail. T-rex had large, powerful back legs and relatively small arms with only two claws.

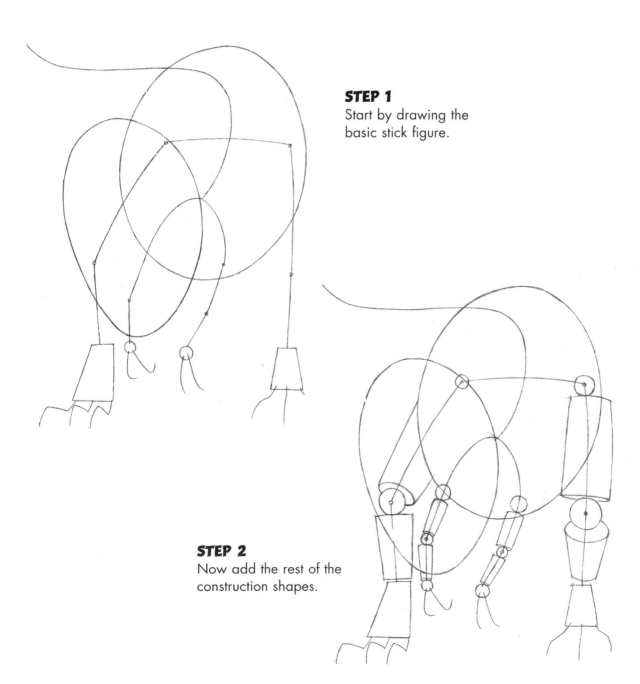

STEP 1
Start by drawing the basic stick figure.

STEP 2
Now add the rest of the construction shapes.

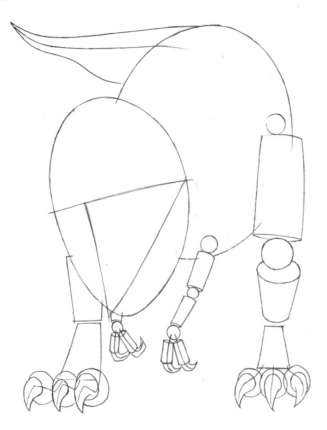

STEP 3

Plot the T-rex's jaws by drawing a line across the middle of the head then add a triangle underneath the line. Add the claws and tail, then remove your stick-figure lines.

STEP 4

Now develop the T-rex's distinctive head shape. Draw in the face and teeth. Go around the construction shapes to add the skin.

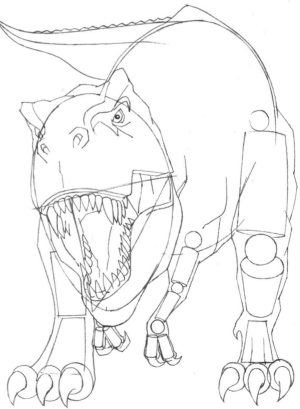

STEP 5

Carefully remove all of your construction shapes and it's time to concentrate on the details. Add creases and scales to the skin, leaving the areas you want to shade blank.

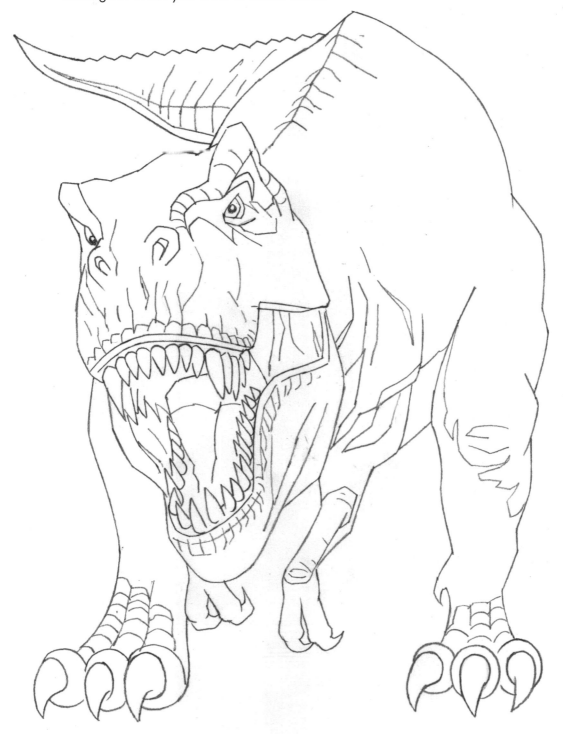

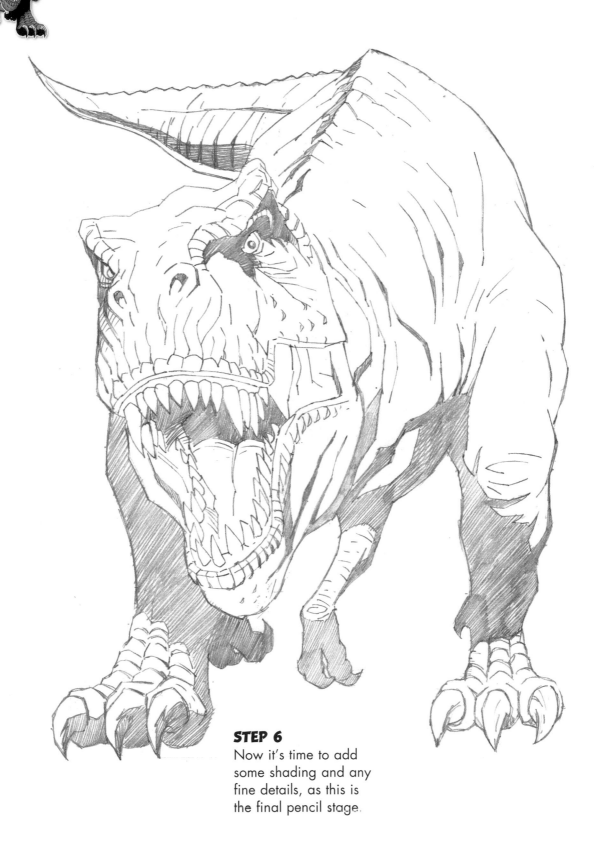

STEP 6
Now it's time to add some shading and any fine details, as this is the final pencil stage.

STEP 7
Now ink over the pencil line. Bold shading will give your drawing perspective and a dramatic effect.

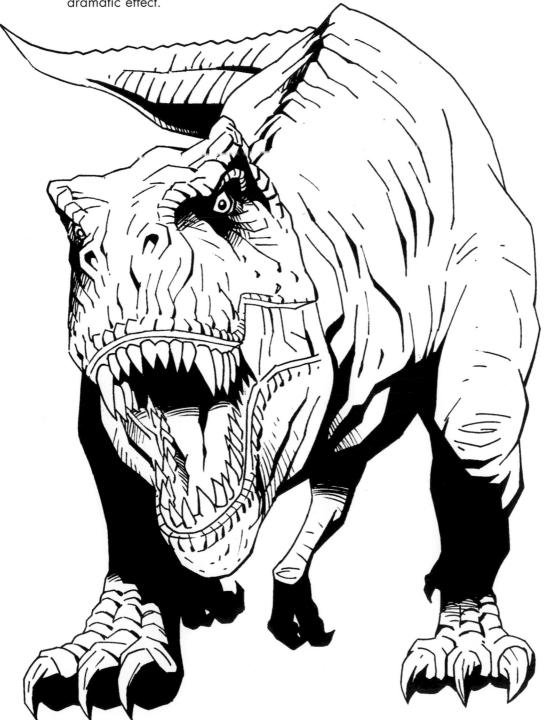

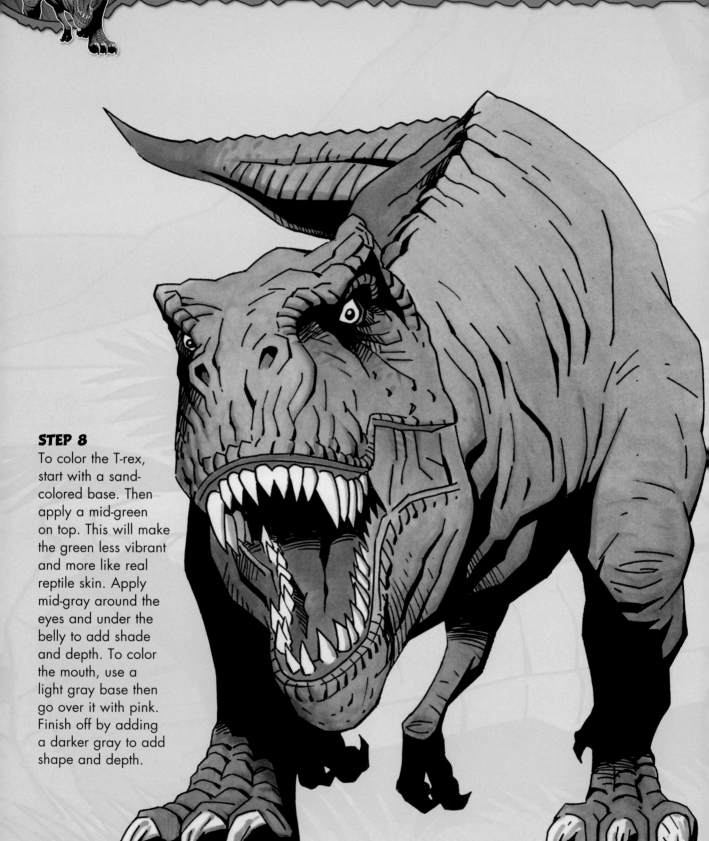

STEP 8

To color the T-rex, start with a sand-colored base. Then apply a mid-green on top. This will make the green less vibrant and more like real reptile skin. Apply mid-gray around the eyes and under the belly to add shade and depth. To color the mouth, use a light gray base then go over it with pink. Finish off by adding a darker gray to add shape and depth.

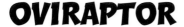

OVIRAPTOR

DINO FACT FILE

This birdlike predator's name means "egg thief" because the first fossil specimen was discovered on top of a pile of eggs. Scientists aren't sure if it preferred to eat meat, eggs, nuts, fish, insects, or a bit of everything. However, its sharp beak, claws, and the egg-breaking teeth on the roof of its mouth suggest it could take its pick. It grew to 6.6 feet/2 meters tall and was a fast runner.

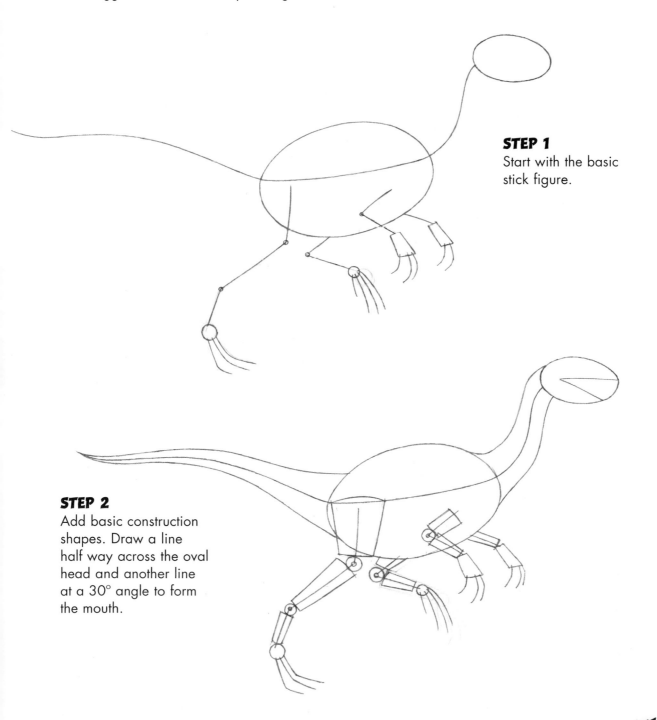

STEP 1
Start with the basic stick figure.

STEP 2
Add basic construction shapes. Draw a line half way across the oval head and another line at a 30° angle to form the mouth.

STEP 3
Define Oviraptor's beak-like mouth and draw the facial features. Add skin and some feathers to the arms. Draw the claws and some creases in the skin. Remove all the basic stick lines.

STEP 4
Erase all of your interior construction shapes. Add more texture and depth to the skin. Draw feathers on its back, down the back of its neck, and add more to its arms. Notice how areas to be shaded in have been left blank.

STEP 5
Now complete the
pencil drawing by
adding shading and
any additional detail
to the skin.

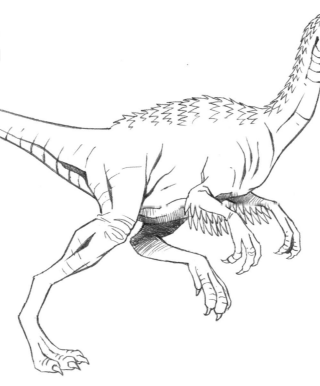

STEP 6
Ink over your final
pencil drawing.

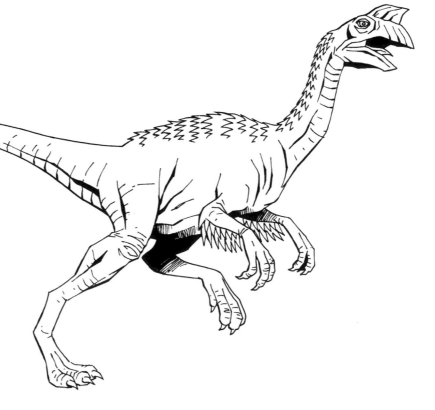

STEP 7

Color the Oviraptor by starting with a
sand-colored base. Add fuschia pink to the
back of the neck and body, gradually fading
down into the sand-colored belly. Now color
the forearm feathers in bright green. Use a
warm red for the crest on top of the head,
and yellow for the beak and eye.

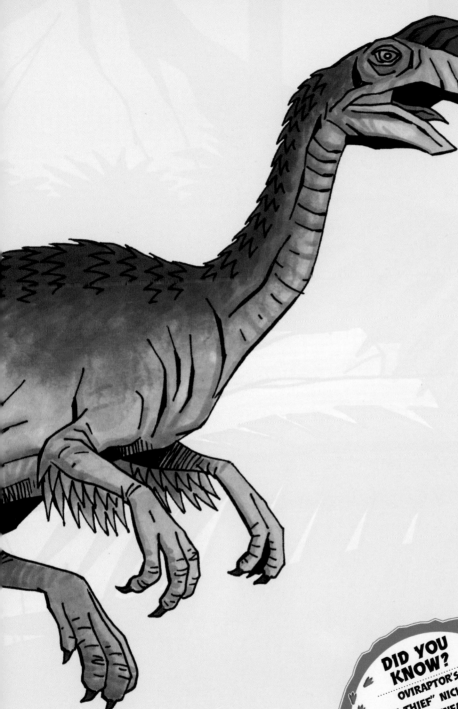

DID YOU KNOW?

OVIRAPTOR'S "EGG THIEF" NICKNAME MIGHT BE UNFAIR. AN OVIRAPTOR FOSSIL WAS FOUND ON A NEST OF ITS OWN EGGS. PERHAPS IT WASN'T STEALING!

VELOCIRAPTOR

DINO FACT FILE

Velociraptor meaning "speedy raider" was a fast-running, two-legged dinosaur that preferred to hunt in a pack. This predator had about 80 very sharp, curved teeth in its long, flat snout. It had an S-shaped neck, three-fingered clawed hands, long thin legs, and four-toed clawed feet. One of these claws was particularly large, and was a formidable weapon for sinking into its prey.

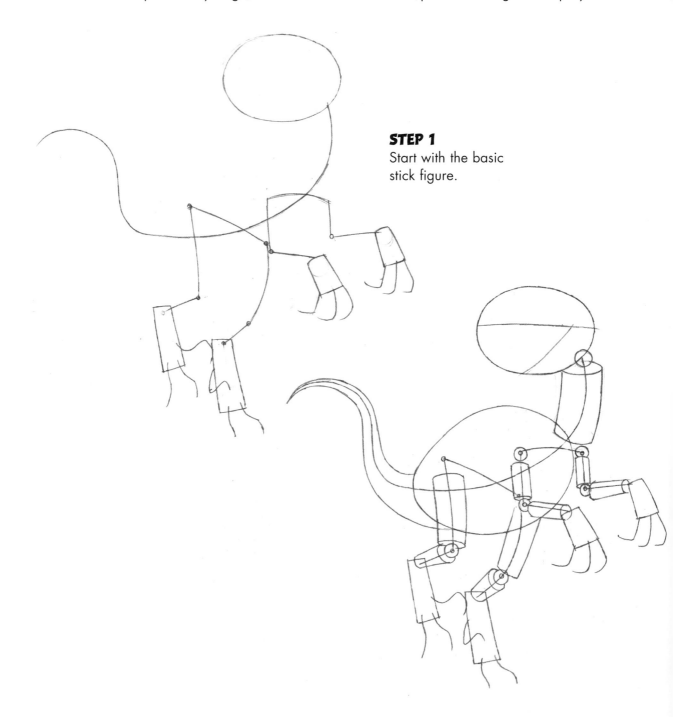

STEP 1
Start with the basic stick figure.

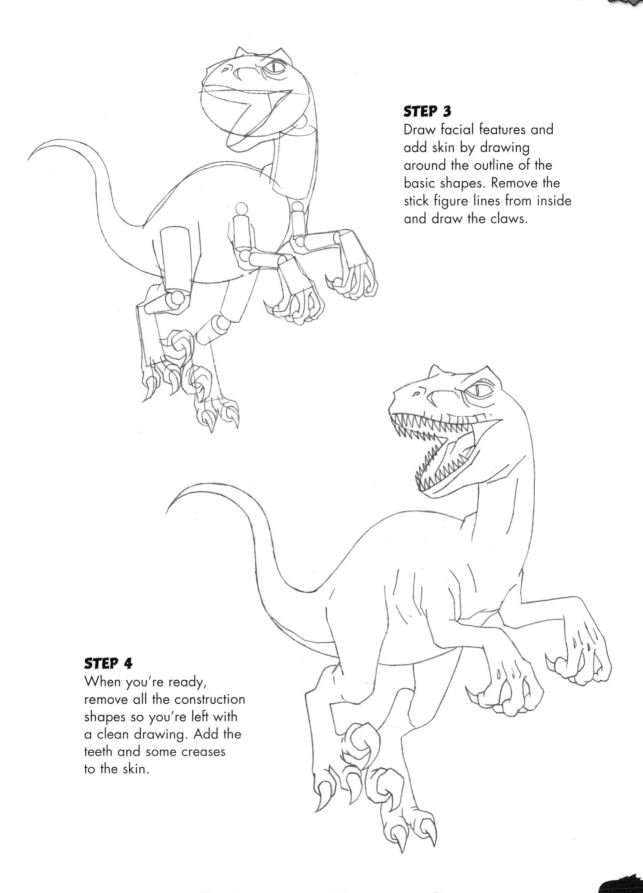

STEP 3
Draw facial features and add skin by drawing around the outline of the basic shapes. Remove the stick figure lines from inside and draw the claws.

STEP 4
When you're ready, remove all the construction shapes so you're left with a clean drawing. Add the teeth and some creases to the skin.

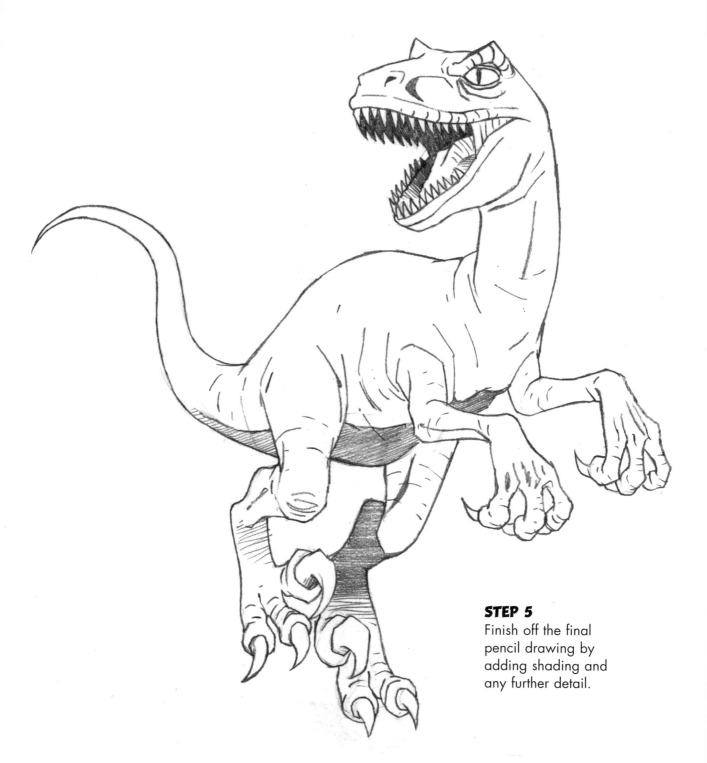

STEP 5
Finish off the final
pencil drawing by
adding shading and
any further detail.

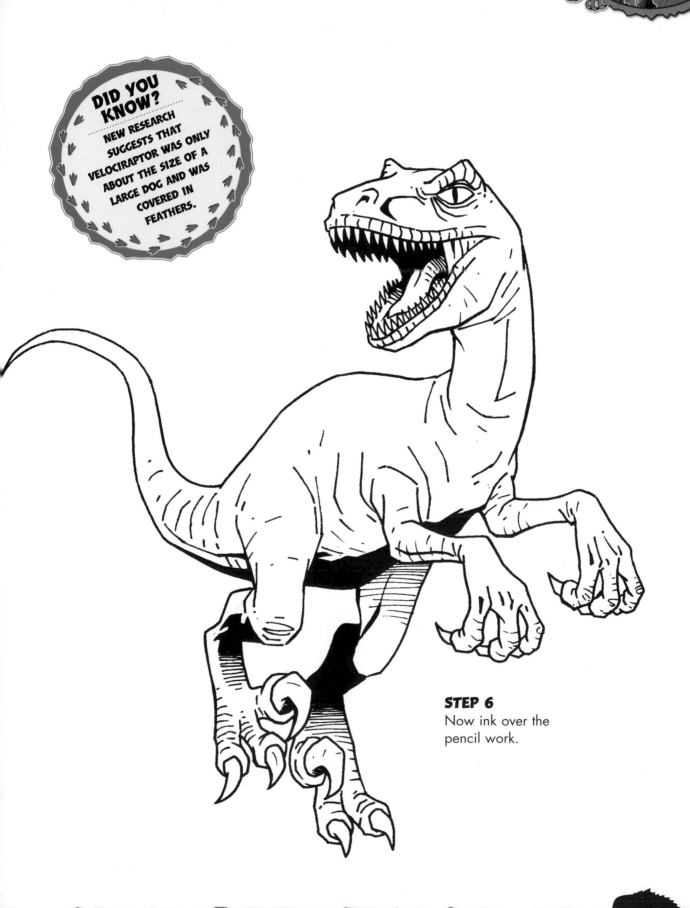

DID YOU KNOW?

NEW RESEARCH SUGGESTS THAT VELOCIRAPTOR WAS ONLY ABOUT THE SIZE OF A LARGE DOG AND WAS COVERED IN FEATHERS.

STEP 6
Now ink over the pencil work.

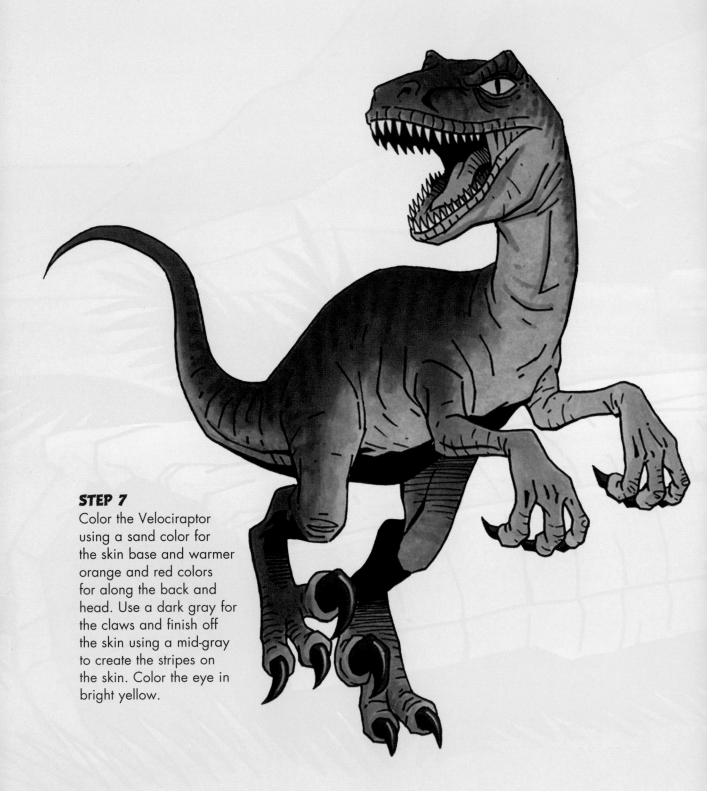

STEP 7

Color the Velociraptor using a sand color for the skin base and warmer orange and red colors for along the back and head. Use a dark gray for the claws and finish off the skin using a mid-gray to create the stripes on the skin. Color the eye in bright yellow.

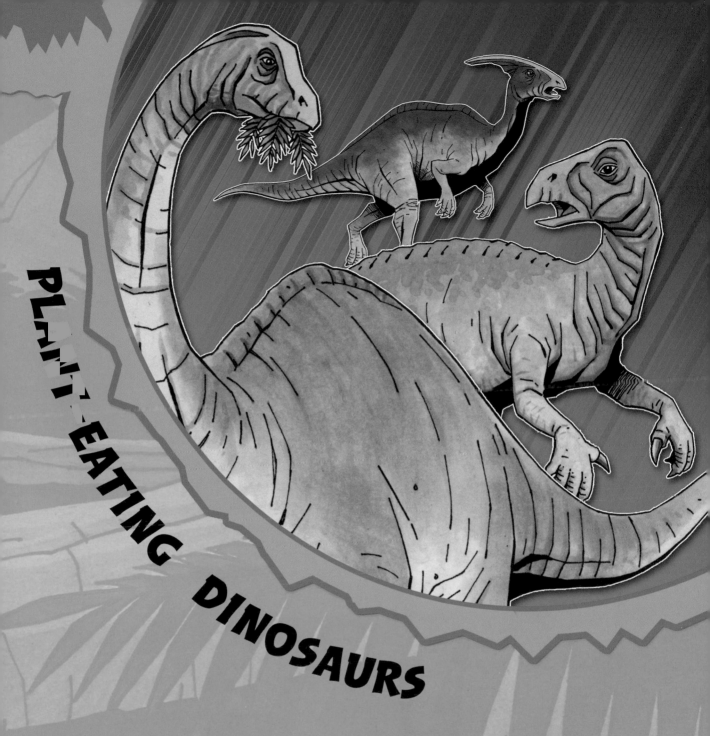

PLANT-EATING DINOSAURS

Without the placid plant eaters, meat-loving dinosaurs like T-rex would have been a great deal hungrier! Scientists think that about 65 percent of all dinosaurs were herbivores that snacked solely on plants.

Plant eaters came in all different shapes, sizes and categories. Big sauropods like Diplodocus had long, powerful necks and tails, ornithopods like Iguanodon could move fast and had sharp thumb claws, and hadrosaurs like Parasaurolophus had strange crests on their heads. Most plant eaters needed to swallow stones, which would grind up their food in the stomach, as they had very blunt teeth.

All species of plant-eating dinosaurs had special features to help defend themselves from predators. In this section you'll learn how to draw three very different looking plant eaters.

DIPLODOCUS

DINO FACT FILE

Diplodocus was a plant-loving gentle giant. It was one of the largest land animals to have ever existed, measuring about 90 feet/27 meters in length—that's the same as three buses! Its nostrils were on top of its head and its teeth were like pegs. Diplodocus means "double beam," referring to its long neck and powerful tail, which it swung like a whip to defend itself from predators.

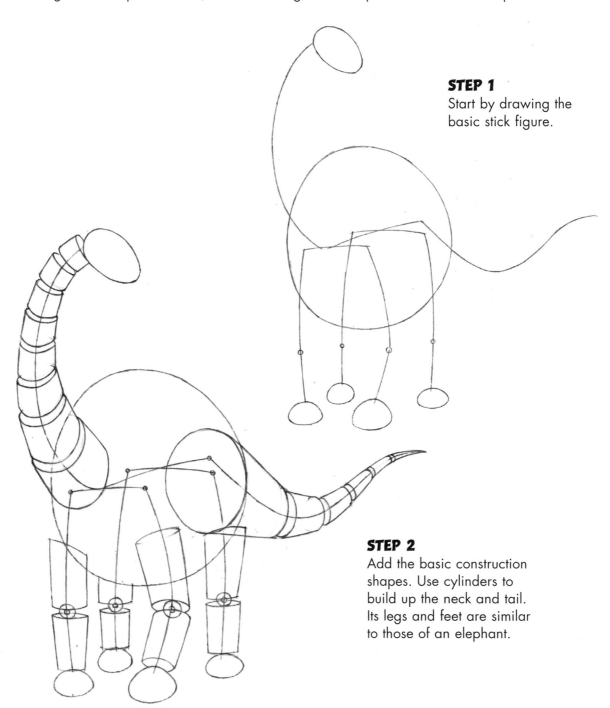

STEP 1
Start by drawing the basic stick figure.

STEP 2
Add the basic construction shapes. Use cylinders to build up the neck and tail. Its legs and feet are similar to those of an elephant.

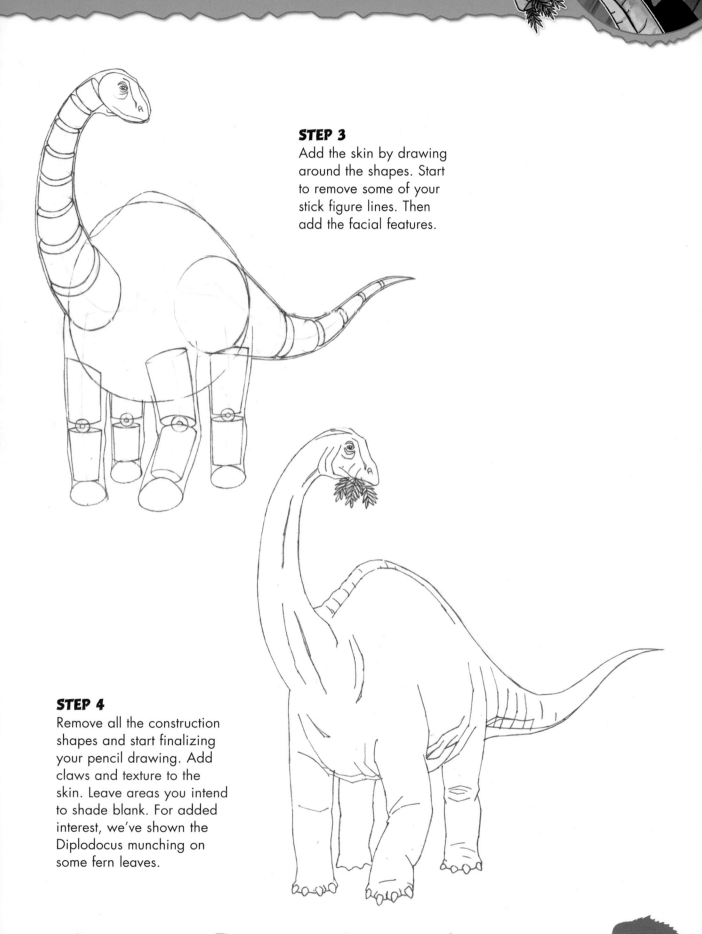

STEP 3
Add the skin by drawing around the shapes. Start to remove some of your stick figure lines. Then add the facial features.

STEP 4
Remove all the construction shapes and start finalizing your pencil drawing. Add claws and texture to the skin. Leave areas you intend to shade blank. For added interest, we've shown the Diplodocus munching on some fern leaves.

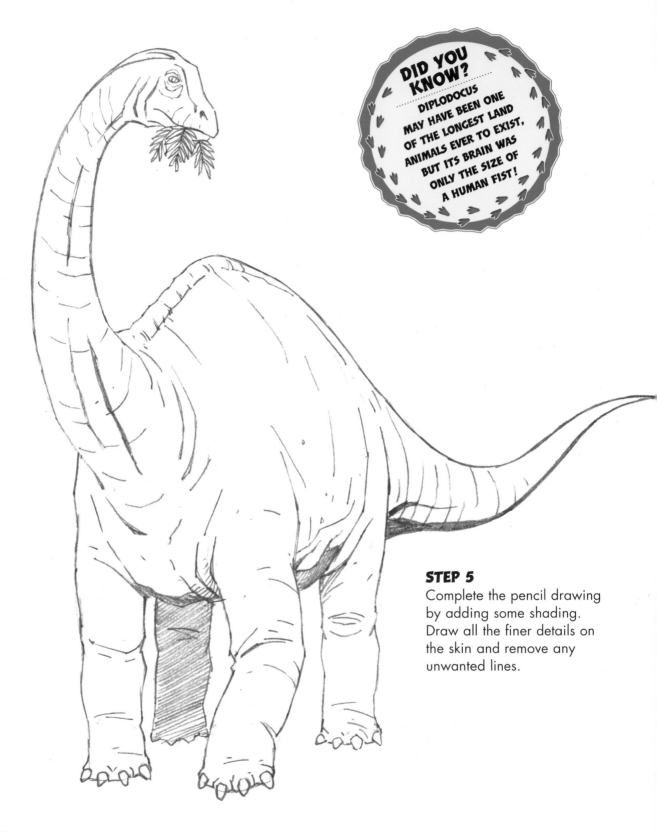

DID YOU KNOW?
.............
DIPLODOCUS MAY HAVE BEEN ONE OF THE LONGEST LAND ANIMALS EVER TO EXIST, BUT ITS BRAIN WAS ONLY THE SIZE OF A HUMAN FIST!

STEP 5
Complete the pencil drawing by adding some shading. Draw all the finer details on the skin and remove any unwanted lines.

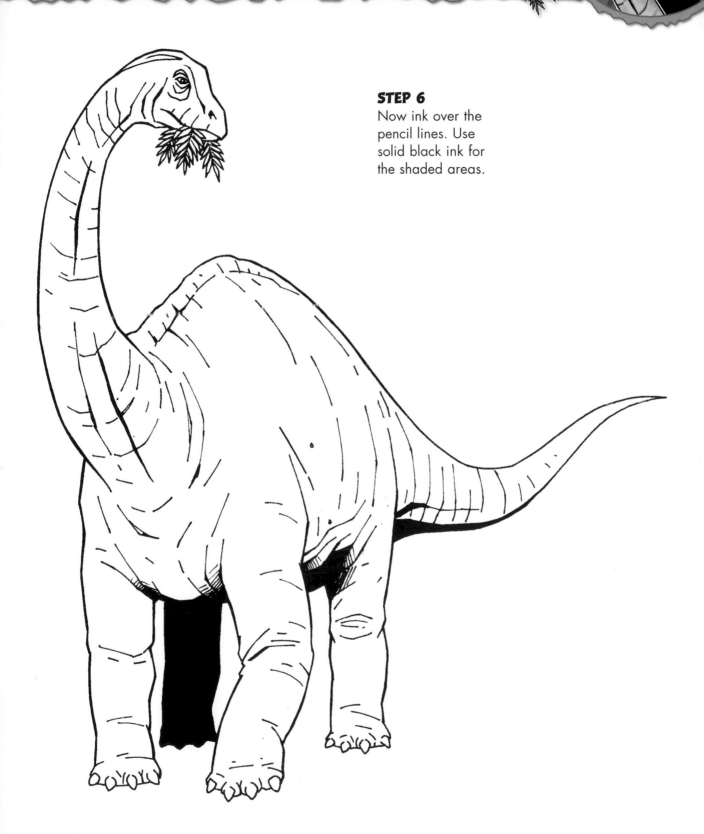

STEP 6
Now ink over the pencil lines. Use solid black ink for the shaded areas.

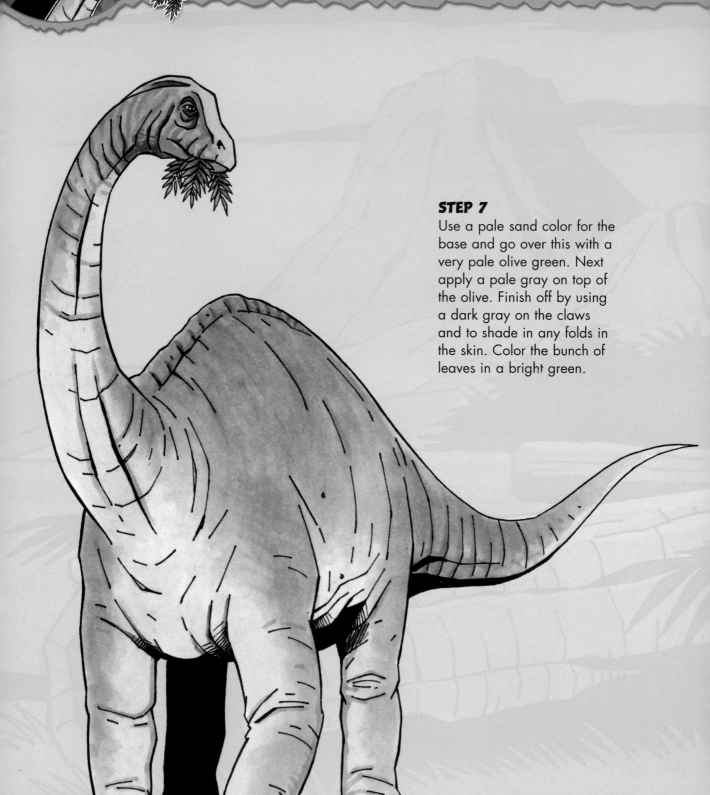

STEP 7

Use a pale sand color for the base and go over this with a very pale olive green. Next apply a pale gray on top of the olive. Finish off by using a dark gray on the claws and to shade in any folds in the skin. Color the bunch of leaves in a bright green.

IGUANODON

DINO FACT FILE

Iguanodon's most distinctive features were its large thumb spikes. These claws were possibly used for defense against predators, or digging up plants to eat. It was one of the first dinosaurs to be discovered and was later named Iguanodon or "iguana tooth." Its pointed beak was completely toothless and all its teeth were in its cheeks. It was able to run on two legs or walk on all fours.

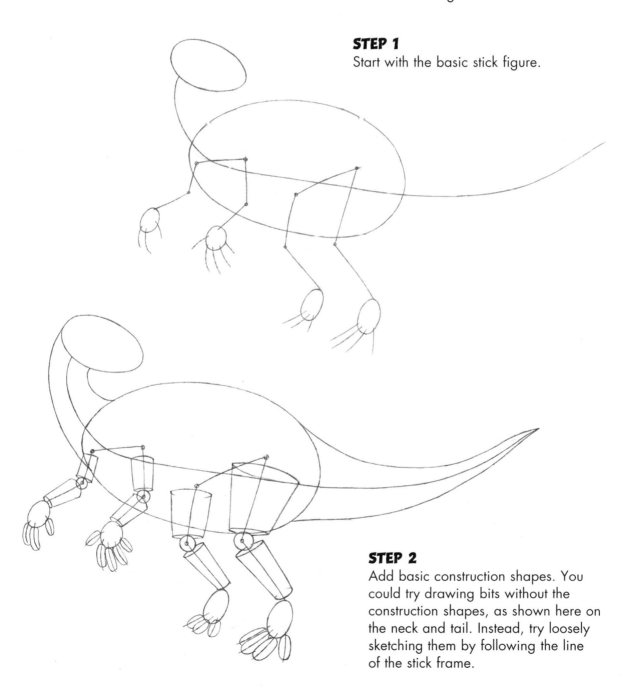

STEP 1
Start with the basic stick figure.

STEP 2
Add basic construction shapes. You could try drawing bits without the construction shapes, as shown here on the neck and tail. Instead, try loosely sketching them by following the line of the stick frame.

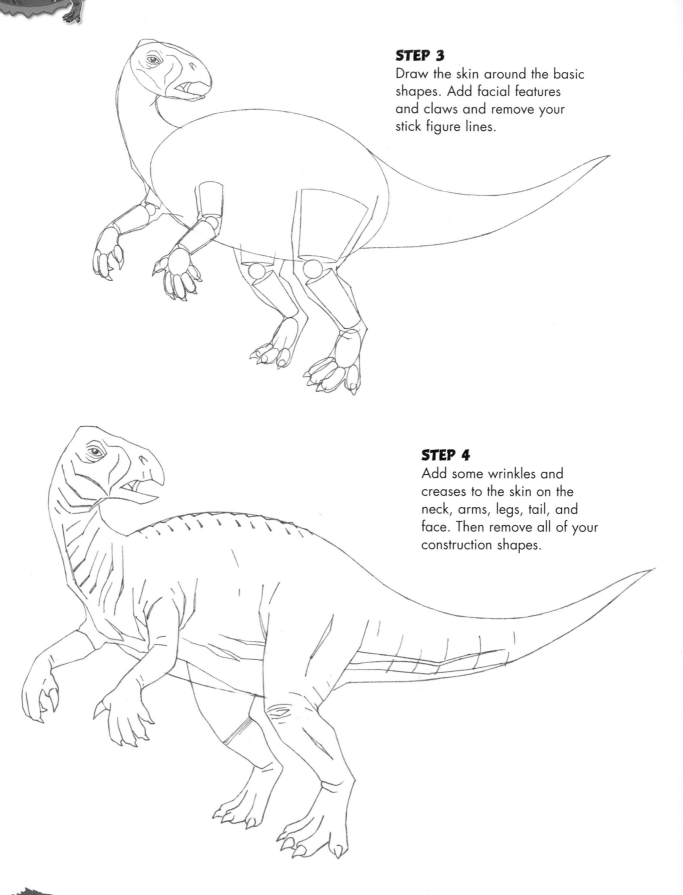

STEP 3
Draw the skin around the basic shapes. Add facial features and claws and remove your stick figure lines.

STEP 4
Add some wrinkles and creases to the skin on the neck, arms, legs, tail, and face. Then remove all of your construction shapes.

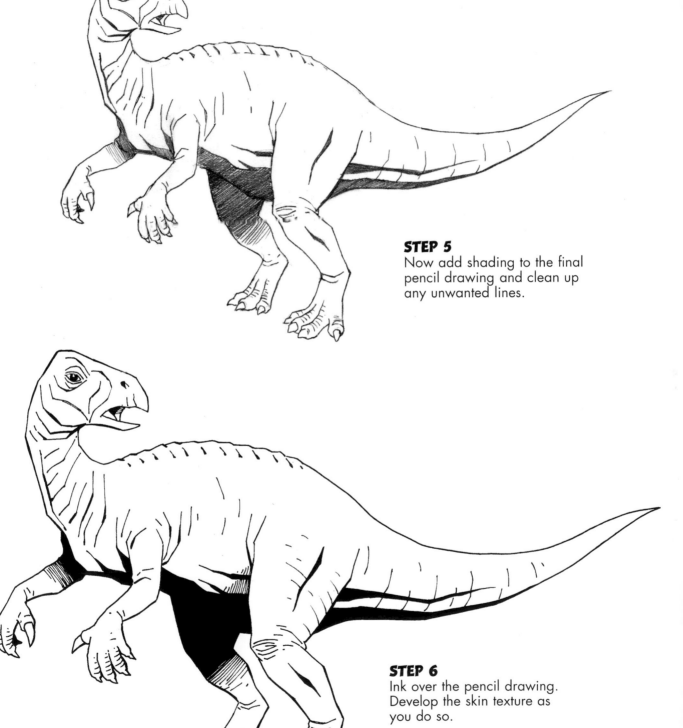

STEP 5
Now add shading to the final pencil drawing and clean up any unwanted lines.

STEP 6
Ink over the pencil drawing. Develop the skin texture as you do so.

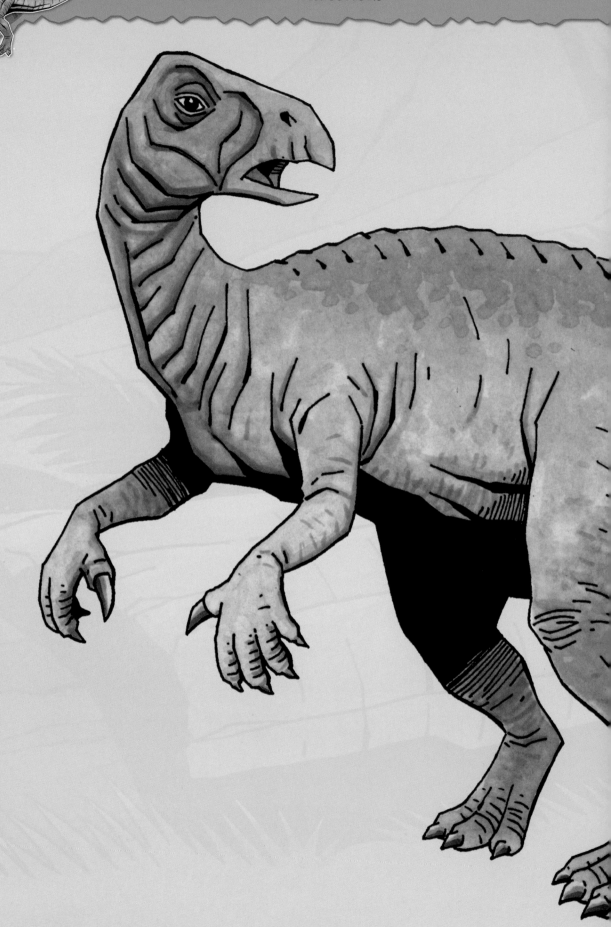

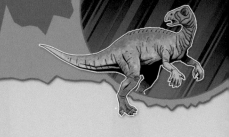

DID YOU KNOW?

IGUANODON WAS ONE OF THE MOST SUCCESSFUL DINOSAUR SPECIES. HUNDREDS OF SPECIMENS HAVE BEEN FOUND ALL OVER THE WORLD.

STEP 7

Start to color the Iguanadon using a sand-colored base. Add a pale olive green down its back and tail and around its head, creating a textured effect. Use a mid-gray to add shading around the creases and folds in the skin and on the claws.

PARASAUROLOPHUS

DINO FACT FILE

Parasaurolophus was a sturdy, duck-billed dinosaur thats distinguishing feature was a hollow, bony crest on its head. It had pebble-like scales and, like Iguanodon, a toothless beak and cheek teeth. Its crest is believed to have enhanced its sense of smell, as its nostrils ran all the way up it and back down in four tubes. This would have helped its survival as it had no natural defenses.

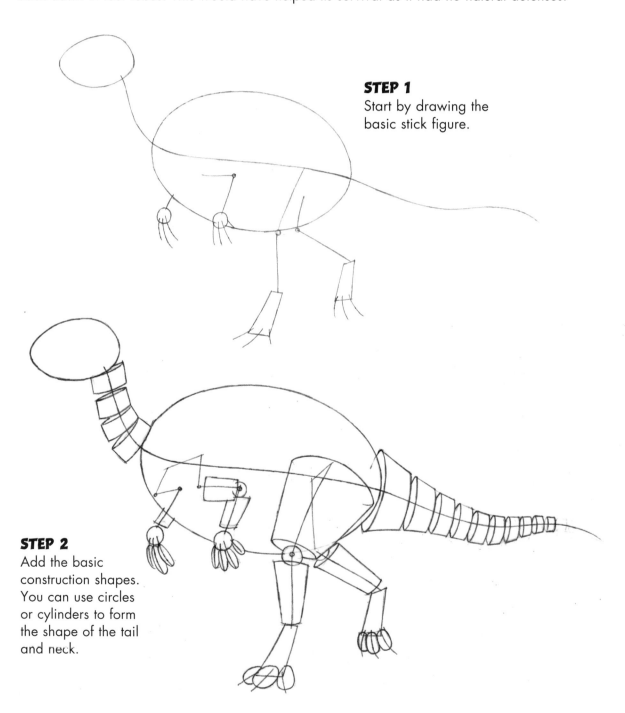

STEP 1
Start by drawing the basic stick figure.

STEP 2
Add the basic construction shapes. You can use circles or cylinders to form the shape of the tail and neck.

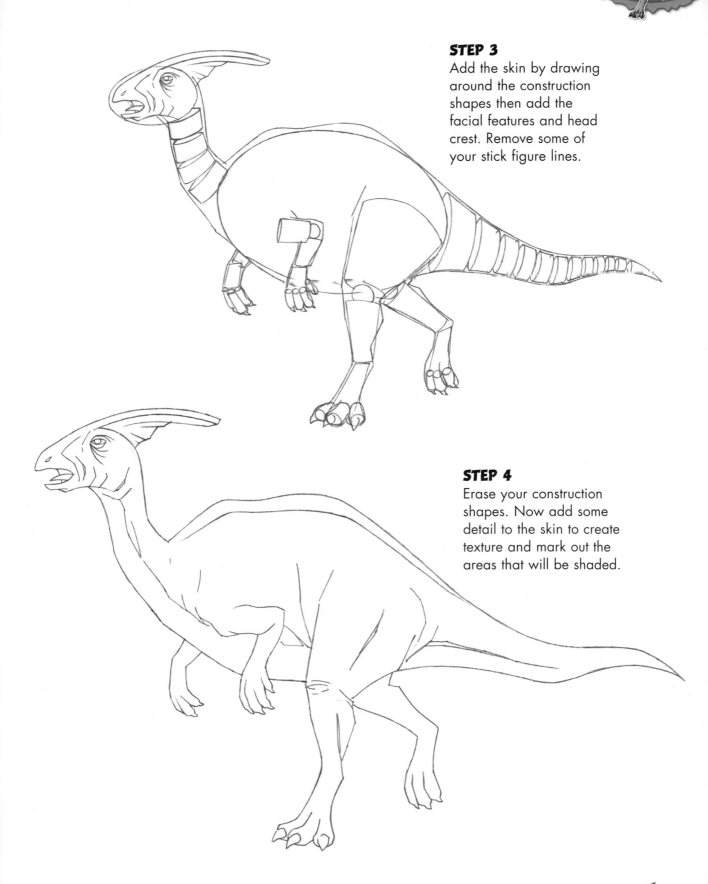

STEP 3
Add the skin by drawing around the construction shapes then add the facial features and head crest. Remove some of your stick figure lines.

STEP 4
Erase your construction shapes. Now add some detail to the skin to create texture and mark out the areas that will be shaded.

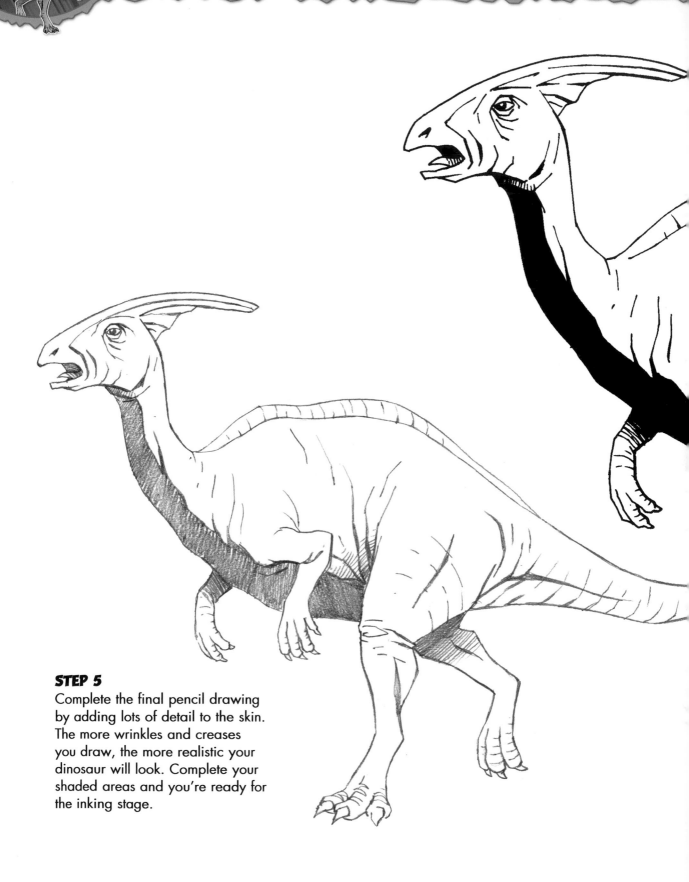

STEP 5
Complete the final pencil drawing by adding lots of detail to the skin. The more wrinkles and creases you draw, the more realistic your dinosaur will look. Complete your shaded areas and you're ready for the inking stage.

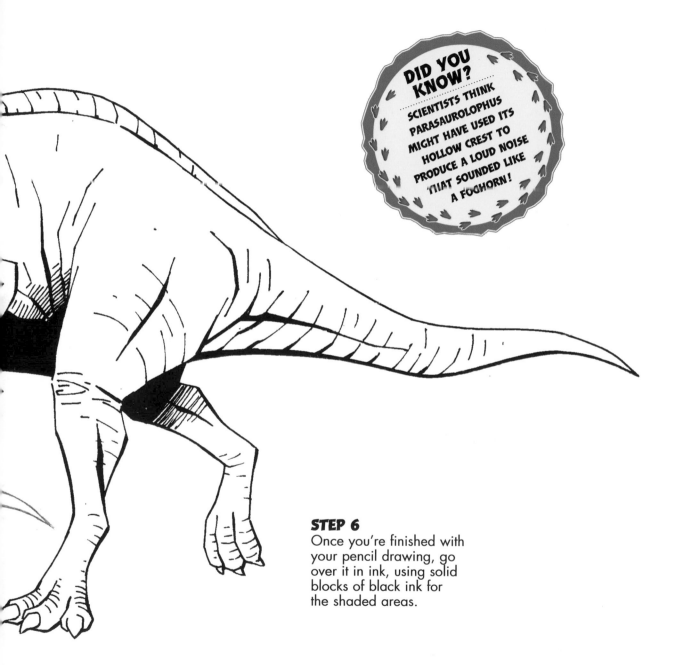

DID YOU KNOW?

SCIENTISTS THINK PARASAUROLOPHUS MIGHT HAVE USED ITS HOLLOW CREST TO PRODUCE A LOUD NOISE THAT SOUNDED LIKE A FOGHORN!

STEP 6
Once you're finished with your pencil drawing, go over it in ink, using solid blocks of black ink for the shaded areas.

STEP 7

Color the Parasaurolophus by starting with a sand-colored base. Then use a peach color on its back, neck, tail, and face. Leave the top half of the crest in the sandy base color. Finish off by using a mid-pink on top of the peach color. A slightly patchy appearance will give the skin a textured effect.

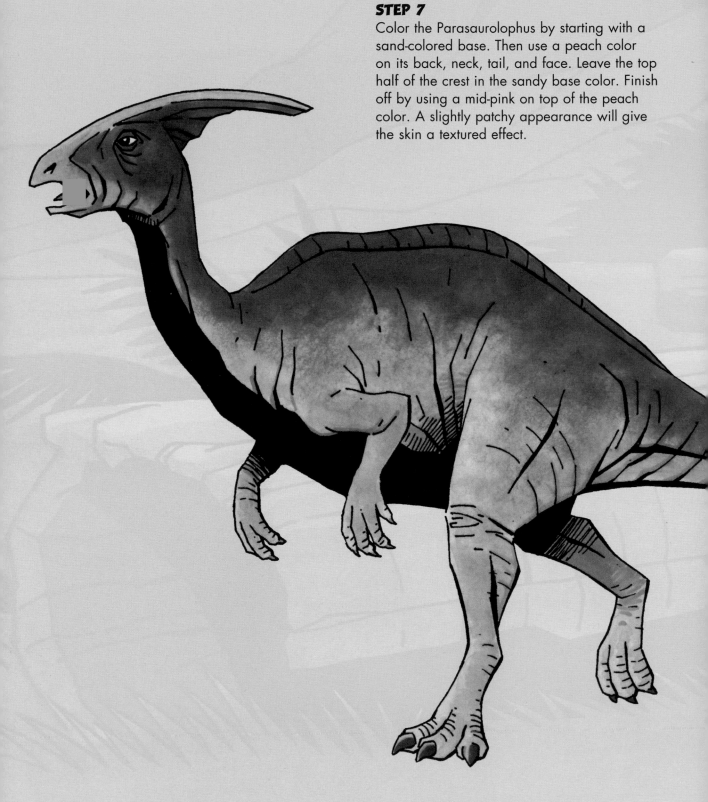

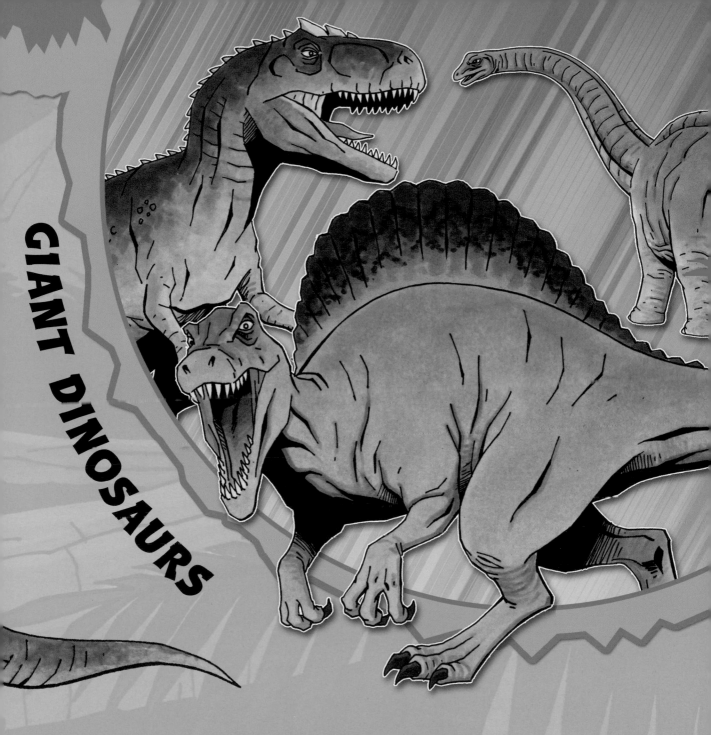

GIANT DINOSAURS

The longer dinosaurs roamed the Earth, the bigger they became. Temperatures got warmer and more vegetation grew, providing plant eaters with an all-you-can-eat supply of food. Their growth also meant that there was more meat for the carnivores—Earth became the land of the giants.

Dinosaurs are also thought to have become less fussy about what they ate. Meat eaters, which previously would only have hunted herbivores, started eating other meat eaters, fish, and larger sea creatures. This could also be because the huge long-necked dinsaurs were simply too big and heavy to tackle.

In this section you'll learn how to draw three record-breaking giant dinosaurs. These monsters all look very different but they have one thing in common—they were all gigantic!

GIGANOTOSAURUS

DINO FACT FILE

Giganotosaurus was discovered in Argentina in 1994 and it's believed to be the largest carnivore due to its overall size—even bigger than T-rex. This terrifying predator measured 45 feet/14 meters in length. Its skull alone was 6 feet/1.8 meters long and housed rows of sharp serrated teeth, each measuring 8 inches/20 centimeters in length. Even more scarily, they hunted in packs.

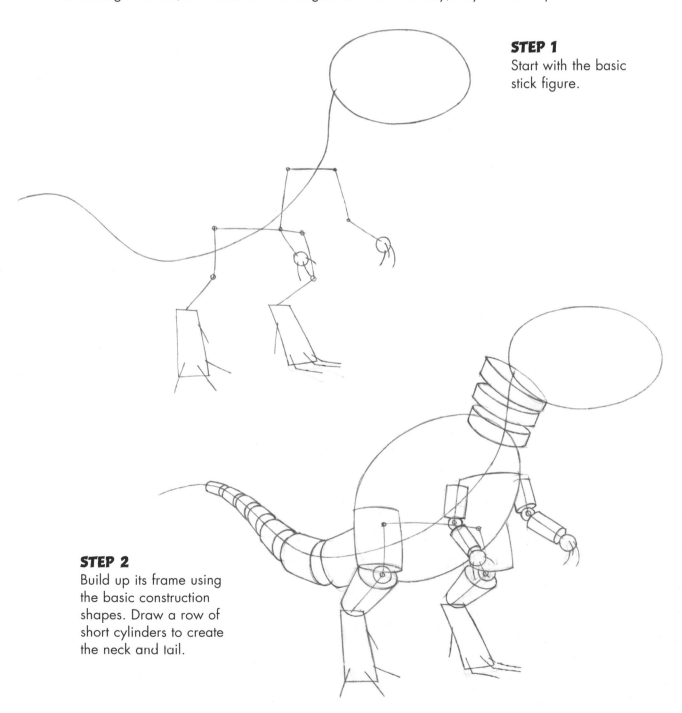

STEP 1
Start with the basic stick figure.

STEP 2
Build up its frame using the basic construction shapes. Draw a row of short cylinders to create the neck and tail.

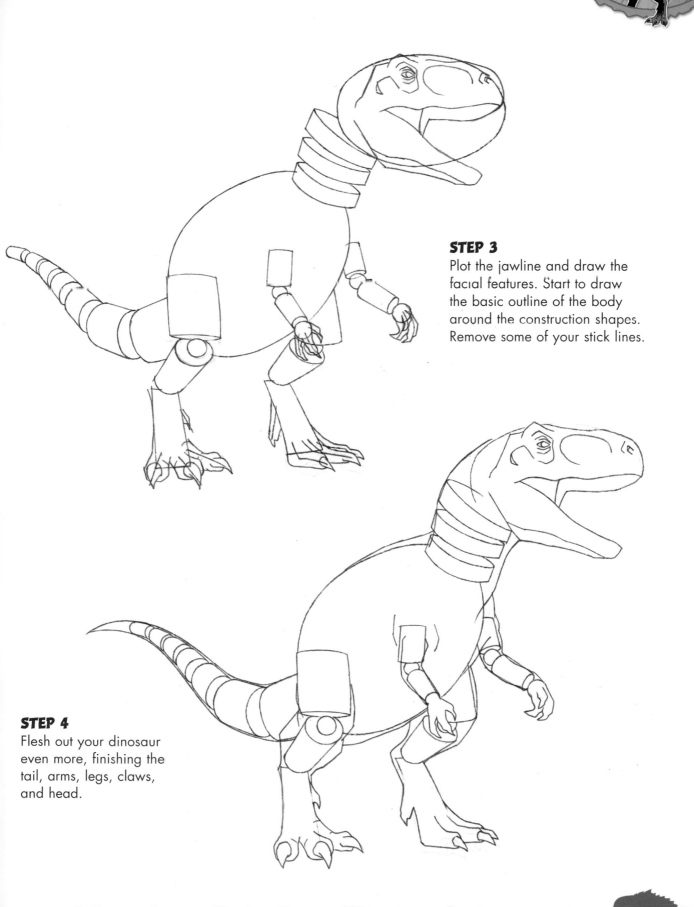

STEP 3

Plot the jawline and draw the facial features. Start to draw the basic outline of the body around the construction shapes. Remove some of your stick lines.

STEP 4

Flesh out your dinosaur even more, finishing the tail, arms, legs, claws, and head.

STEP 5

Now it's time to remove your interior construction shapes. Next draw the teeth and tongue, and start adding detail to the skin. Giganotosaurus had bony spines running down its back and on the top of its head. Leave the areas you want to shade blank.

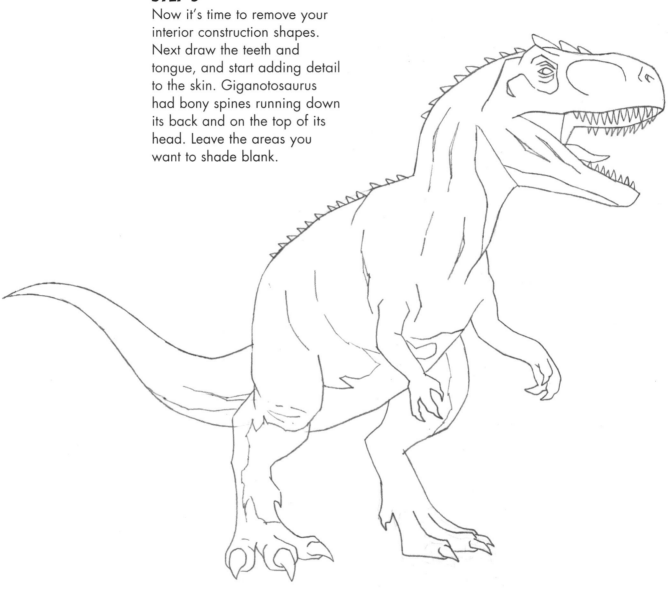

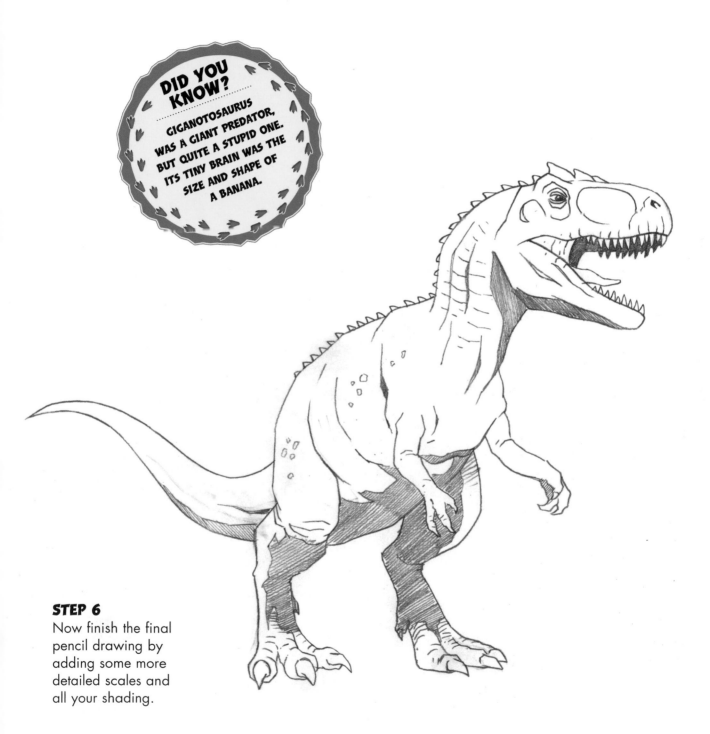

DID YOU KNOW?

GIGANOTOSAURUS WAS A GIANT PREDATOR, BUT QUITE A STUPID ONE. ITS TINY BRAIN WAS THE SIZE AND SHAPE OF A BANANA.

STEP 6
Now finish the final pencil drawing by adding some more detailed scales and all your shading.

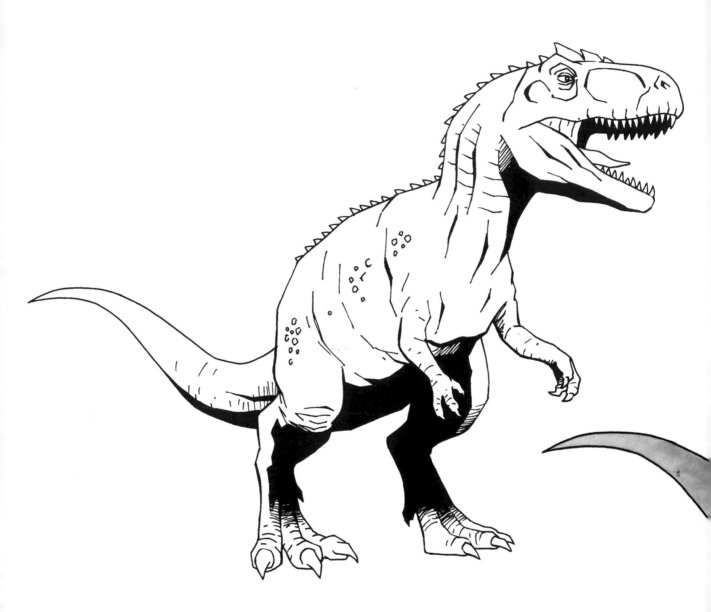

STEP 7

Now ink over the pencil work. Varying the strength of your ink lines will add depth and interest to your final drawing.

STEP 8

Start coloring your Giganotosaurus by applying a sand-colored base all over. Over the top, apply a rustic orange to its back, head, and tail. Add some extra texture and shading to the skin using touches of mid-gray.

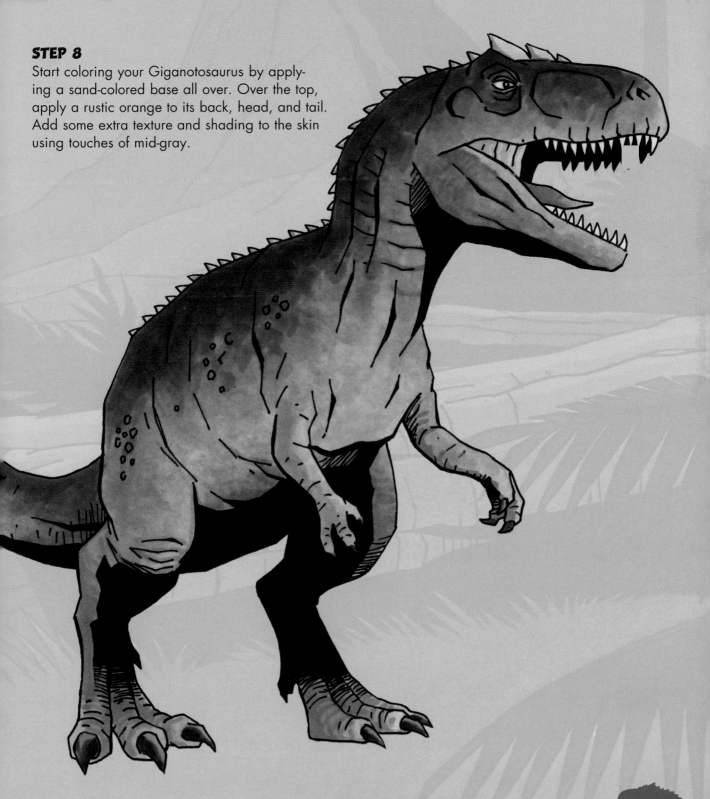

57

ARGENTINOSAURUS

DINO FACT FILE

Argentinosaurus is the largest land animal that's ever been discovered. This plant-eating giant measured 115 feet/35 meters in length and was as tall as a six-story building. Each of its massive backbones was the height of a human. It was so heavy that the ground would have shaken as it moved. It's thought they moved in herds of 20—that must have felt like an earthquake!

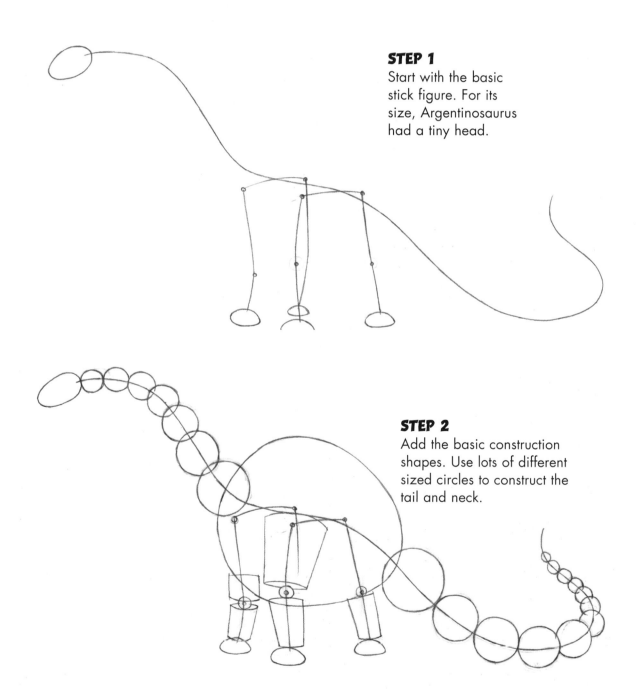

STEP 1

Start with the basic stick figure. For its size, Argentinosaurus had a tiny head.

STEP 2

Add the basic construction shapes. Use lots of different sized circles to construct the tail and neck.

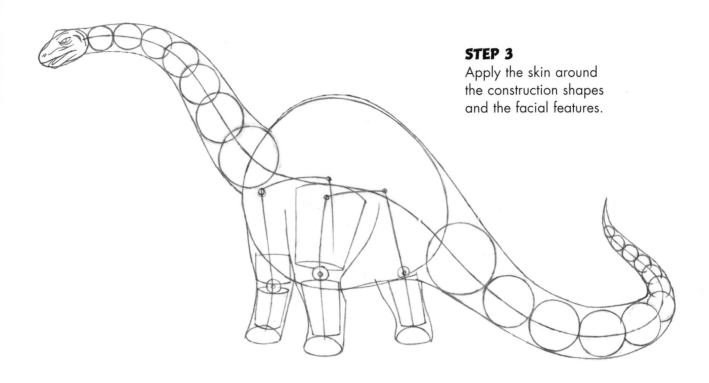

STEP 3
Apply the skin around the construction shapes and the facial features.

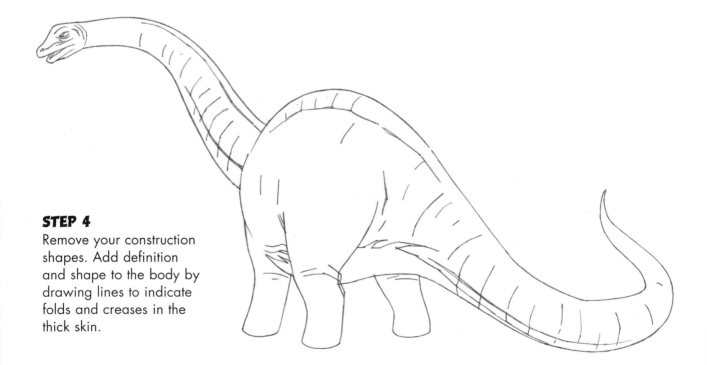

STEP 4
Remove your construction shapes. Add definition and shape to the body by drawing lines to indicate folds and creases in the thick skin.

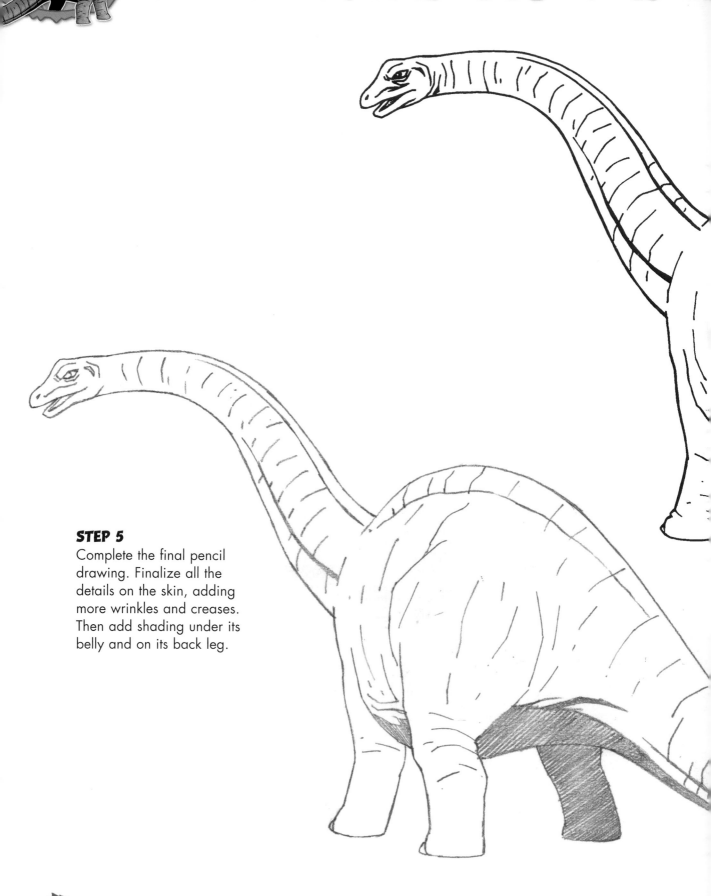

STEP 5
Complete the final pencil drawing. Finalize all the details on the skin, adding more wrinkles and creases. Then add shading under its belly and on its back leg.

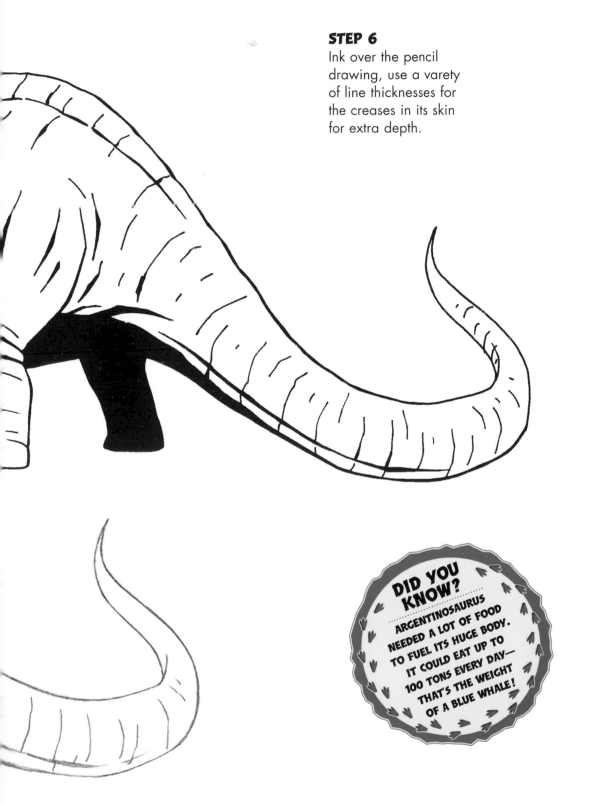

STEP 6
Ink over the pencil drawing, use a varety of line thicknesses for the creases in its skin for extra depth.

DID YOU KNOW?
ARGENTINOSAURUS NEEDED A LOT OF FOOD TO FUEL ITS HUGE BODY. IT COULD EAT UP TO 100 TONS EVERY DAY— THAT'S THE WEIGHT OF A BLUE WHALE!

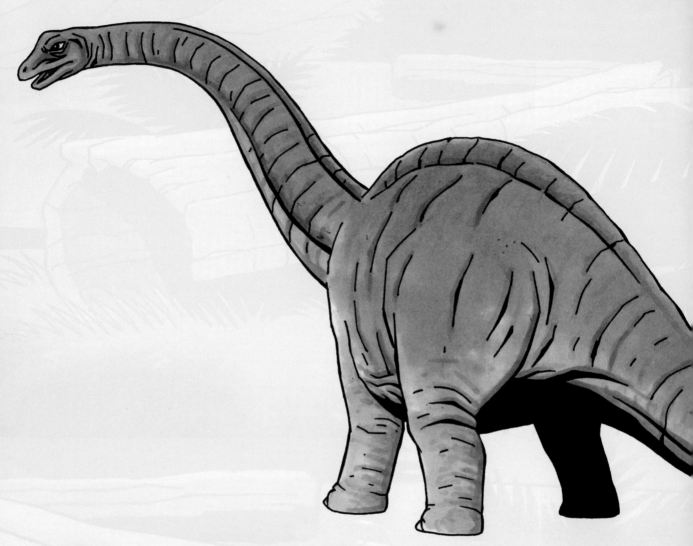

STEP 7

Now it's time to color the Argentinosaurus.
First apply a light gray all over the skin. On top of
the gray base color apply a sand color. Use a very
pale olive green to add shading to the neck and
along the spine. Finish off the dinosaur using a dark
gray to bring out the folds and creases in the skin.

SPINOSAURUS

DINO FACT FILE

Spinosaurus or "spine lizard" was a ferocious meat eater with a massive sail-like structure on its back. Scientists aren't sure what it was for, but think it regulated its body temperature. It was the longest carnivore and measured up to 60 feet/18 meters tall—that's bigger than three giraffes stacked on top of each other! They were highly intelligent with crocodile-like jaws and sharp teeth.

STEP 1
Start by drawing the basic stick figure.

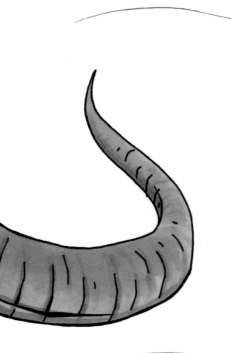

STEP 2
Add your construction shapes. Spinosaurus' jaws are wide open. Draw its face using a triangle for the jaw and a trapezium for the top of its head.

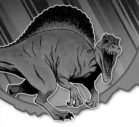

STEP 3

Add the skin by drawing around the shapes. Add a sweeping curve going from the tail to the neck for the dinosaur's big spine. Start to draw in the face and teeth and add the claws.

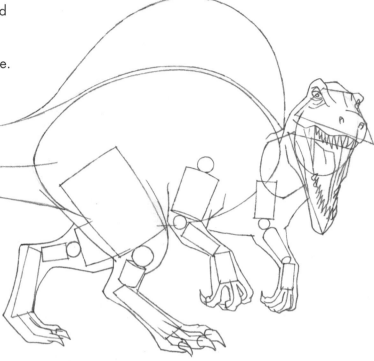

STEP 4

Remove all of your construction shapes and stick lines so you are left with a clean drawing. Add details to the sail-like fin, and to the skin, indicating where shadow will fall.

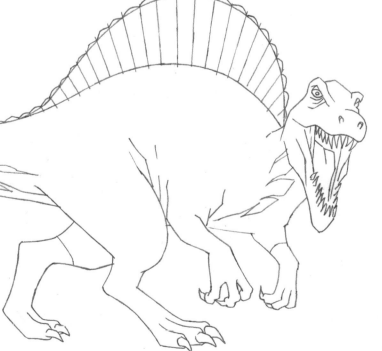

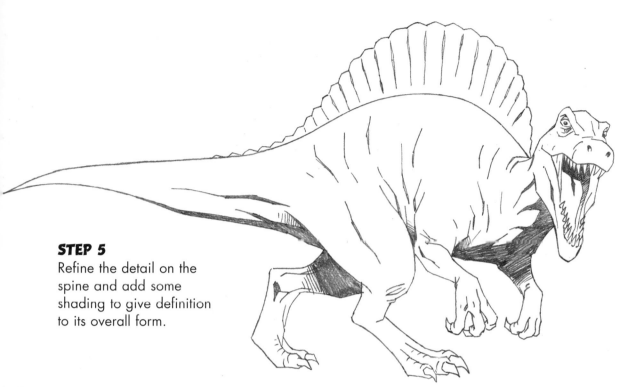

STEP 5

Refine the detail on the spine and add some shading to give definition to its overall form.

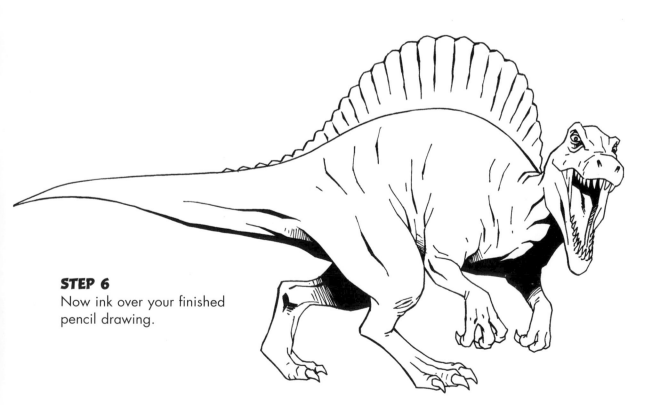

STEP 6

Now ink over your finished pencil drawing.

STEP 7

To color the Spinosaurus, use a very pale sand color for the base, apply it all over the dinosaur's skin. Next add a lime green tone on top of the base. Finish off by using a grass green over the top. Add tone, shadow, and details using a mid-gray, especially in all the creases. Finally, color the spinal fin with bright fuschia pink with gray and yellow markings.

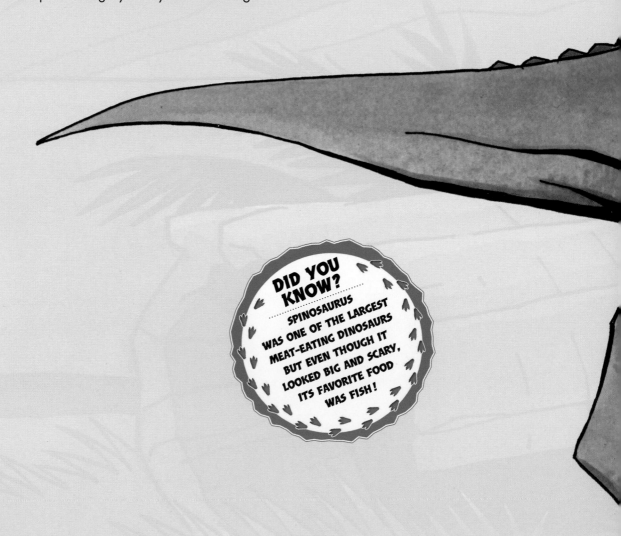

DID YOU KNOW?

SPINOSAURUS WAS ONE OF THE LARGEST MEAT-EATING DINOSAURS BUT EVEN THOUGH IT LOOKED BIG AND SCARY, ITS FAVORITE FOOD WAS FISH!

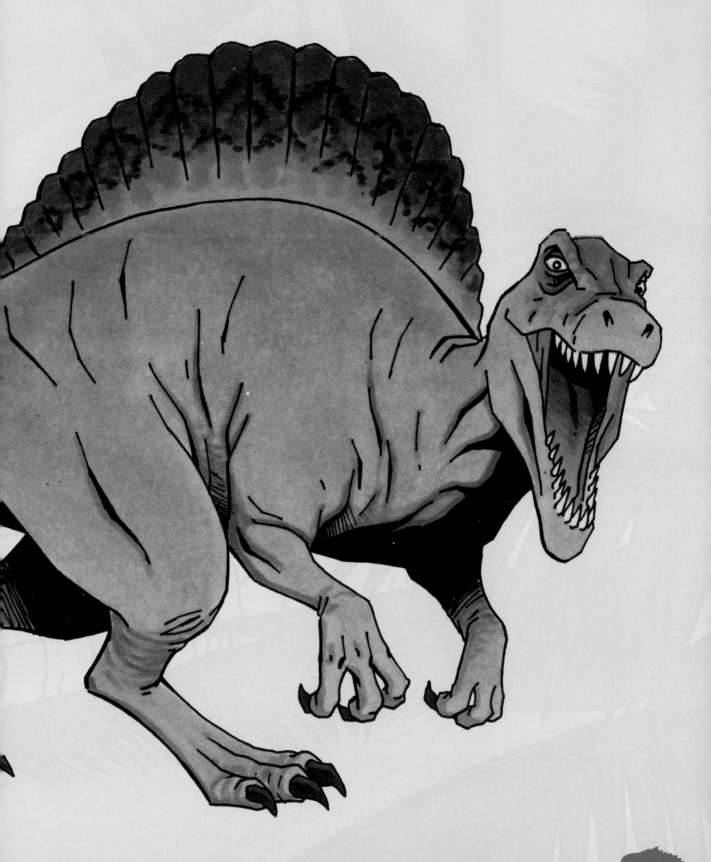

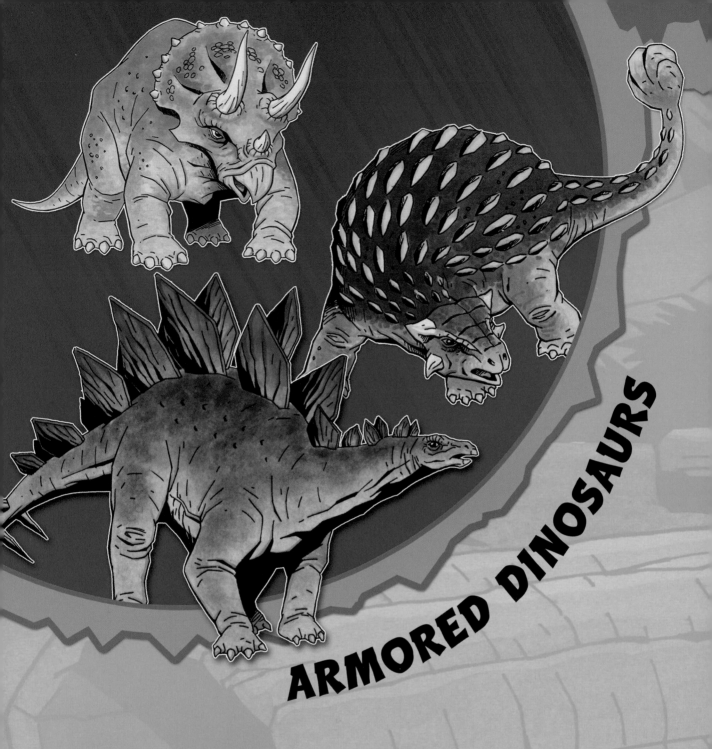

ARMORED DINOSAURS

Some plant-eating dinosaurs used impressive body armor to defend themselves from predators. While others grew to huge sizes as a defense, this group of dinosaurs were armed with spikes, plates, horns, and club tails.

All that body armor made carnivores think twice about making a meal of these dinosaurs. If a T-rex risked biting into the tough skin of Ankylosaurus, it would have broken its teeth!

The armored dinosaurs were generally quite slow with beak-like mouths and fairly small brains for their size.

These factors made them vulnerable, but scientists now believe that some species' body armor was bullet-proof by today's standards, so they were well protected.

In this section you'll learn how to draw three of the most amazing armored creatures.

STEGOSAURUS

DINO FACT FILE

Stegosaurus was a plant eater with an intimidating appearance. It was as big as a bus and had plenty of defense mechanisms on its body, starting with 17 bony plates running along its back in two rows. These plates continued down its tail, which it could swing around to defend itself and at its tip were sharp pointed spikes. All of its armor made up for its lack of teeth and tiny brain.

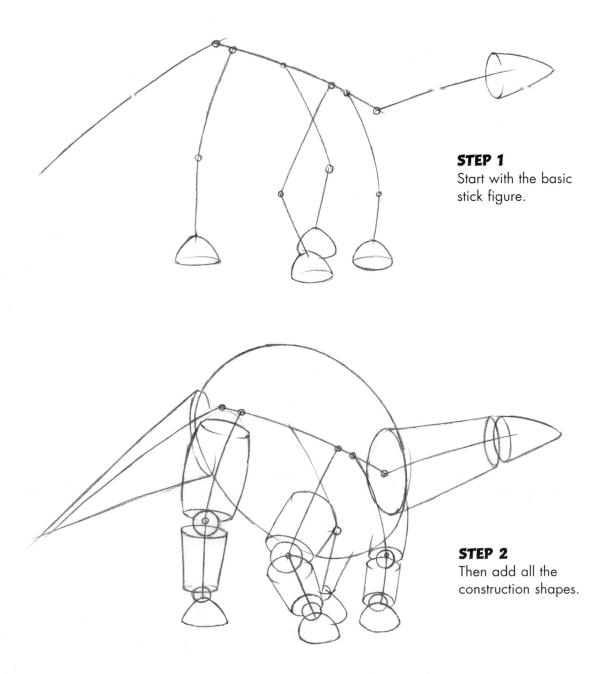

STEP 1
Start with the basic stick figure.

STEP 2
Then add all the construction shapes.

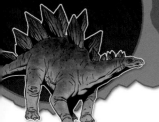

STEP 3
Add the skin by drawing around the construction shapes. Draw the plates on the back, neck, and tail. Add the claws and the mouth. Remove some of your stick line framework.

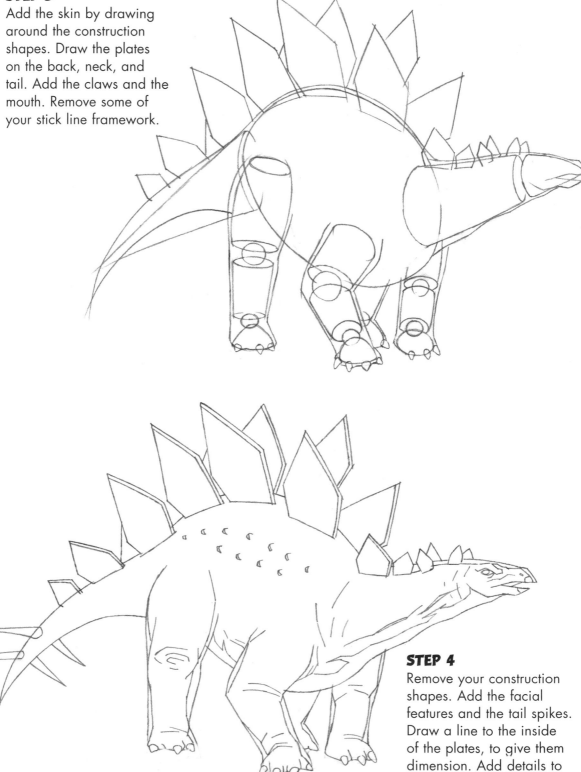

STEP 4
Remove your construction shapes. Add the facial features and the tail spikes. Draw a line to the inside of the plates, to give them dimension. Add details to the arms, legs, and skin.

STEP 5

Finish the pencil drawing by adding details to the plates and skin, and add some shading.

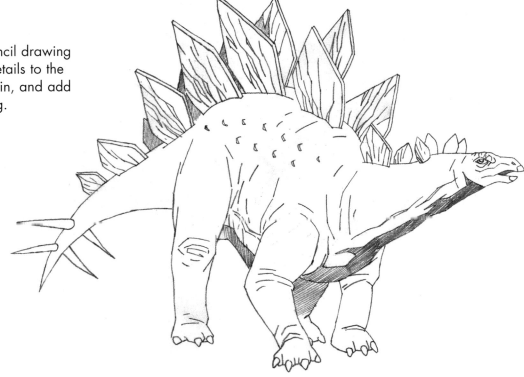

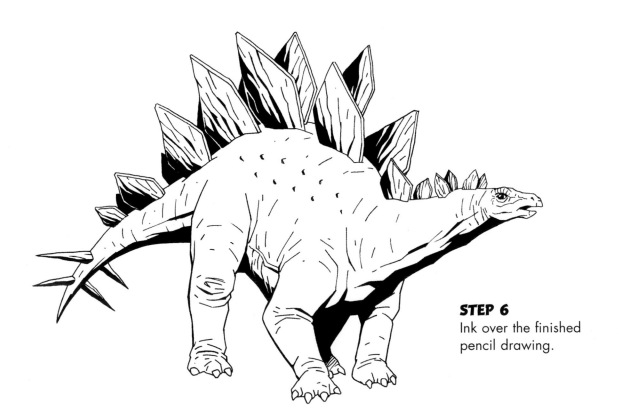

STEP 6

Ink over the finished pencil drawing.

STEP 7

Color the Stegosaurus using a
sand-colored base. For the next layer,
use a very pale gray. On top of
the gray, apply a pale olive green,
leaving areas of the sand color
untouched around the underbelly and
under the neck and tail. Using a dark
olive green add texture to the skin
along the back. Color the armored
plates on its back using yellow and
orange. See pages 15–17 for a
step-by-step guide to coloring the
Stegosaurus.

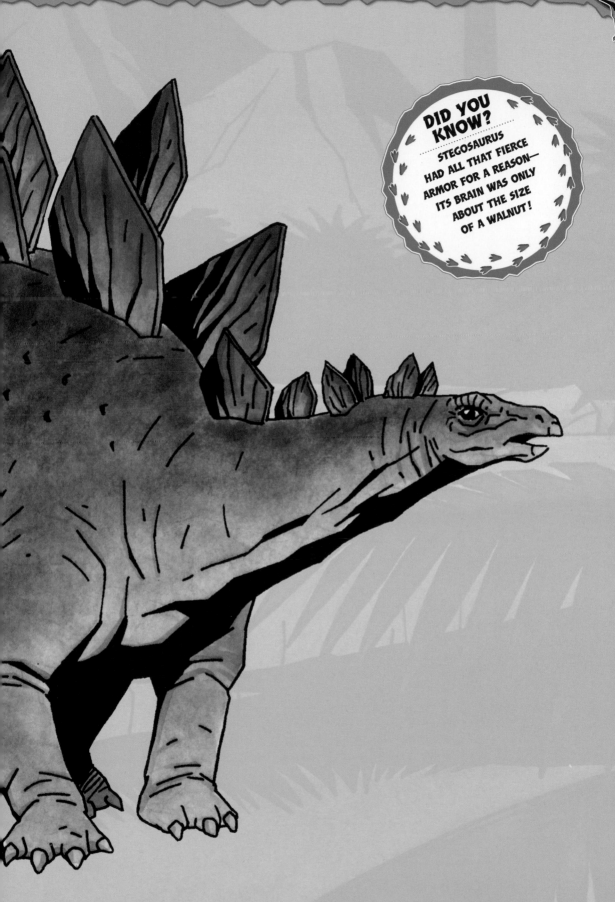

DID YOU KNOW?

STEGOSAURUS HAD ALL THAT FIERCE ARMOR FOR A REASON— ITS BRAIN WAS ONLY ABOUT THE SIZE OF A WALNUT!

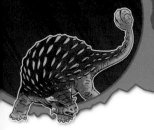

ANKYLOSAURUS

DINO FACT FILE

Ankylosaurus was a huge plant eater with very impressive body armor. Its whole top side was covered in thick oval-shaped plates and sharp spikes. It had a powerful clublike tail and even its eyes had special protective eye plates. The only way to hurt it was by flipping it over, exposing its soft belly. It's thought to have been fairly fast on its feet, but, like Stegosaurus, it had a tiny brain.

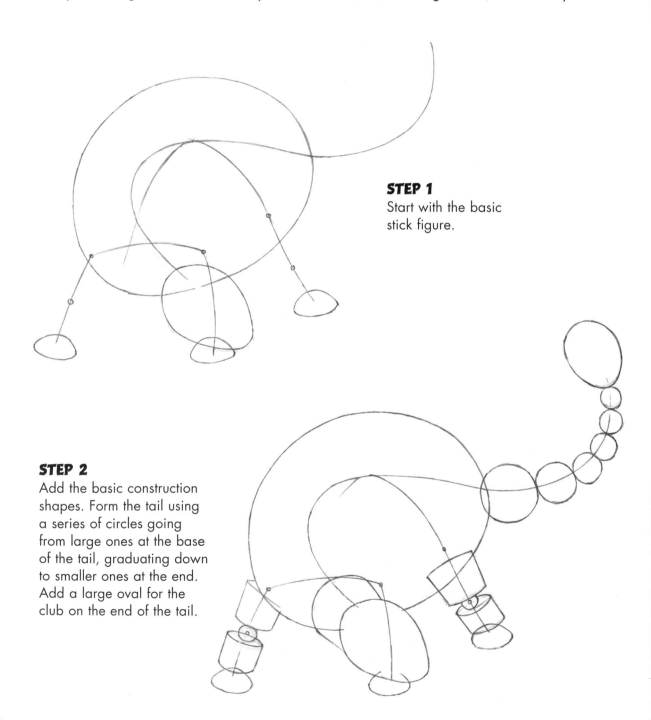

STEP 1

Start with the basic stick figure.

STEP 2

Add the basic construction shapes. Form the tail using a series of circles going from large ones at the base of the tail, graduating down to smaller ones at the end. Add a large oval for the club on the end of the tail.

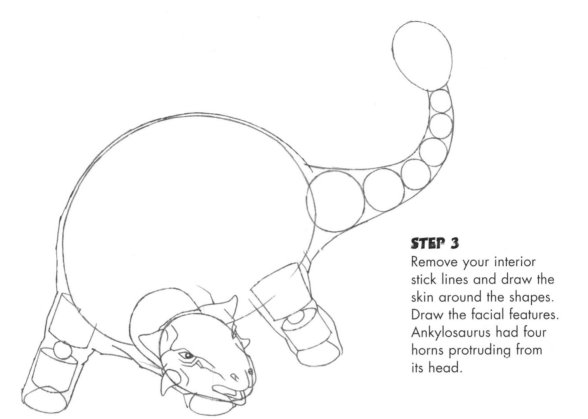

STEP 3

Remove your interior stick lines and draw the skin around the shapes. Draw the facial features. Ankylosaurus had four horns protruding from its head.

STEP 4

Erase your construction shapes. Add the claws on its feet and give definition to the skin with lines and creases. Now draw its armor plates. Start each one as an elongated oval with a central line. Then refine each plate using uneven lines to give them a realistic appearance.

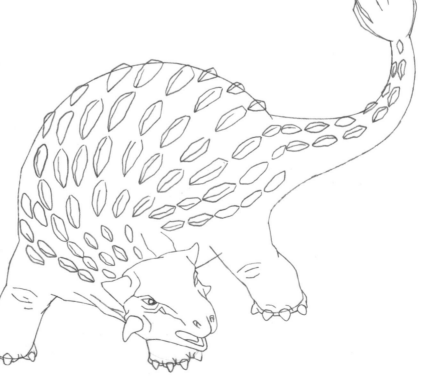

STEP 5

Finish the pencil drawing off by adding shading. Notice how the shading on the armor plates gives added perspective. Finalize the face and club tail and remove any unwanted lines.

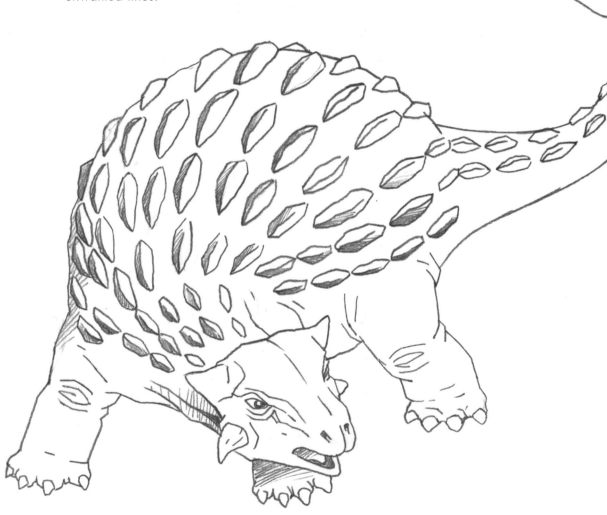

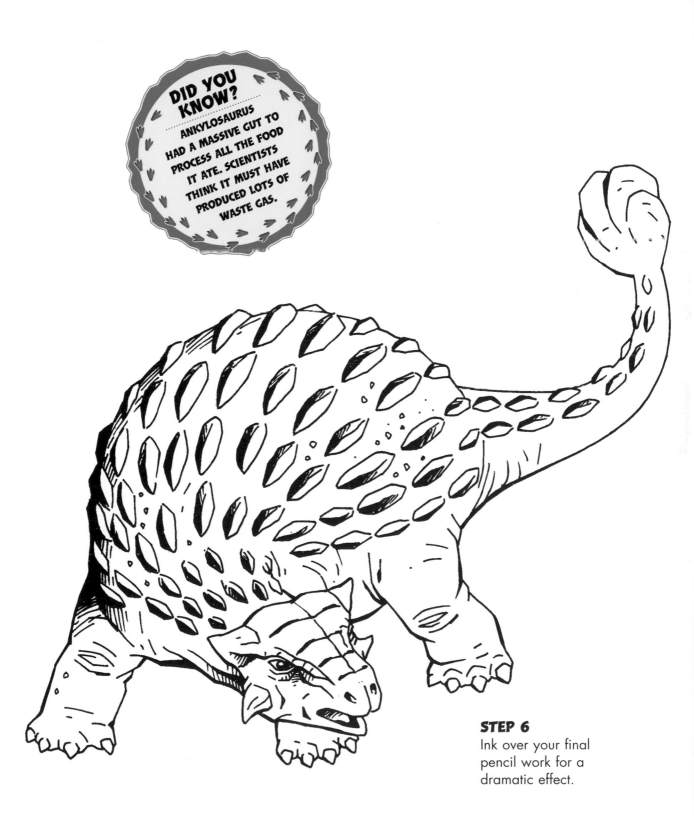

DID YOU KNOW?

ANKYLOSAURUS HAD A MASSIVE GUT TO PROCESS ALL THE FOOD IT ATE. SCIENTISTS THINK IT MUST HAVE PRODUCED LOTS OF WASTE GAS.

STEP 6

Ink over your final pencil work for a dramatic effect.

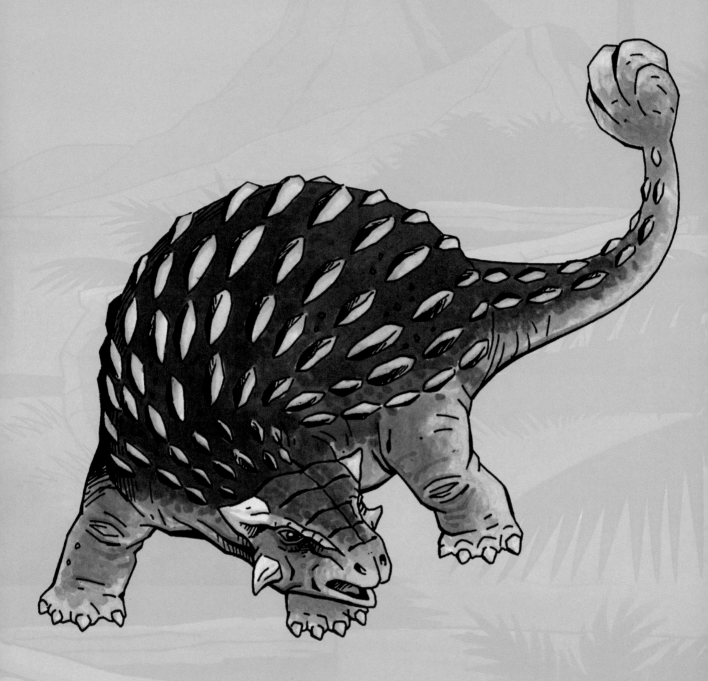

STEP 7

Color the Ankylosaurus starting with a light gray base for the skin color. Next apply a mid-gray over the top, leaving areas of the light gray visible around the underbelly and tail. For the back and the top of the head, go over with dark gray. Use a light cream color for all of its armor—plates, horns, and claws.

TRICERATOPS

DINO FACT FILE

Triceratops is most famous for its big three-horned face, which is exactly what its name means. This sturdy plant eater was like a modern-day rhino and would charge at its predators. Its most effective piece of armor was its big neck frill—a pointed, bony plate tipped with smaller plates. It also had very thick bumpy skin. All of this body armor was well needed—T-rex was one of its predators.

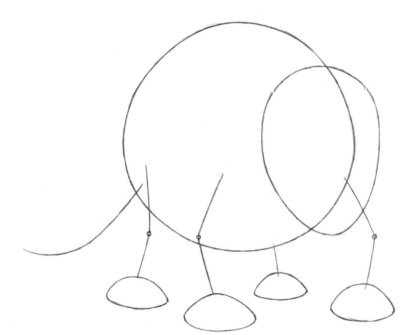

STEP 1

Start with the basic stick figure. At this angle the body is almost circular rather than egg-shaped.

STEP 2

Add the basic construction shapes. Note that the leg cylinders are much wider and stumpier than those of taller dinosaurs.

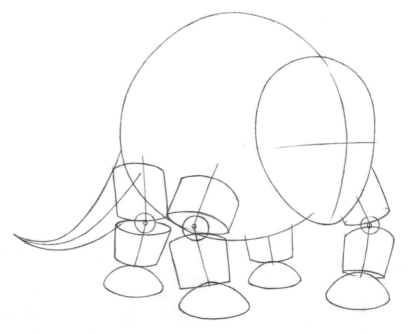

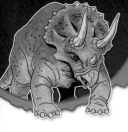

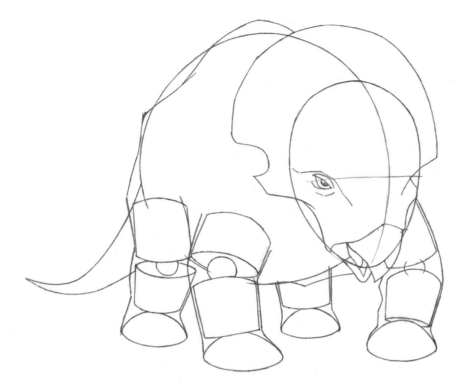

STEP 3

Now draw in the head and face. The mouth is shaped like a beak. When drawing this, slightly extend from the face oval. To create Triceratops' armored head crest, draw a sweeping arc on top of the oval. Now add the skin around the construction shapes.

STEP 4

Add the horns and toes and remove all of your unwanted lines and shapes.

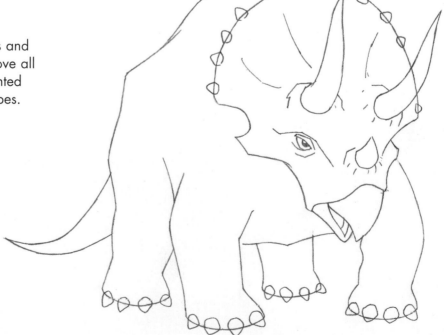

STEP 5

Add details like bumps, creases, and wrinkles to the skin and refine the shape of the legs. Add the first shading around the eye area.

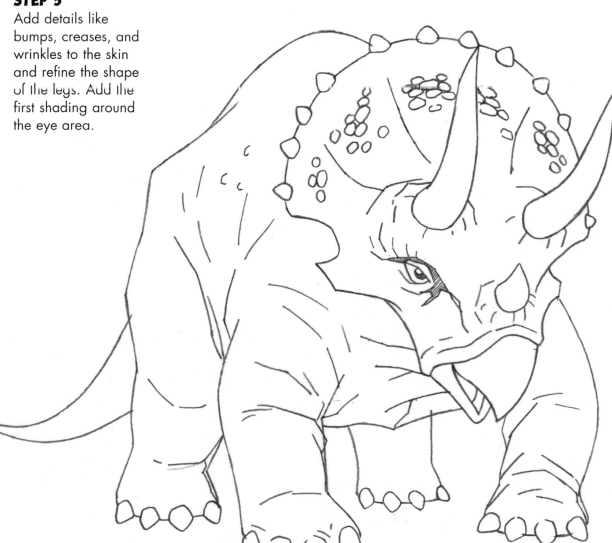

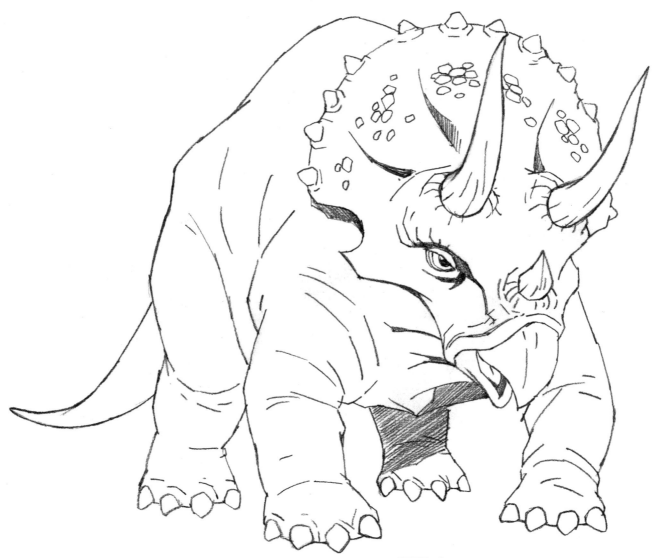

STEP 6

Now finish the pencil drawing by shading in the dark areas to add depth. Add extra detail to the horns, plates, beak, and skin.

DID YOU KNOW?

TRICERATOPS HAD A HUGE SKULL. IT WAS 10 FEET/3 METERS LONG. IT'S ONE OF THE LARGEST SKULLS OF ANY LAND ANIMAL EVER DISCOVERED.

STEP 7

Next ink over the pencil work.

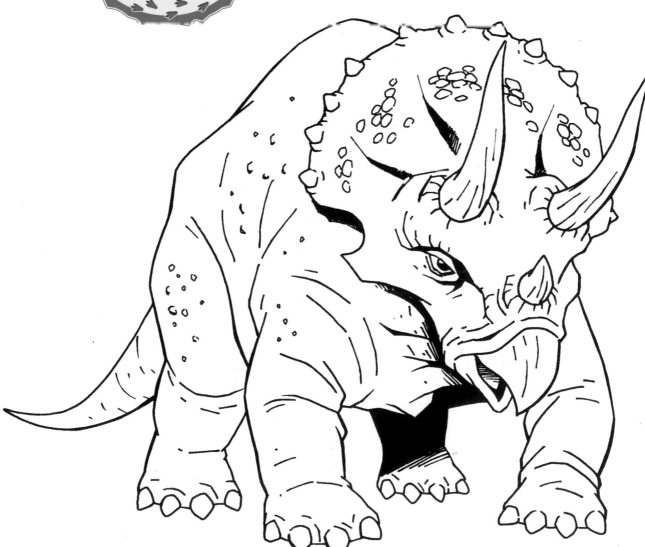

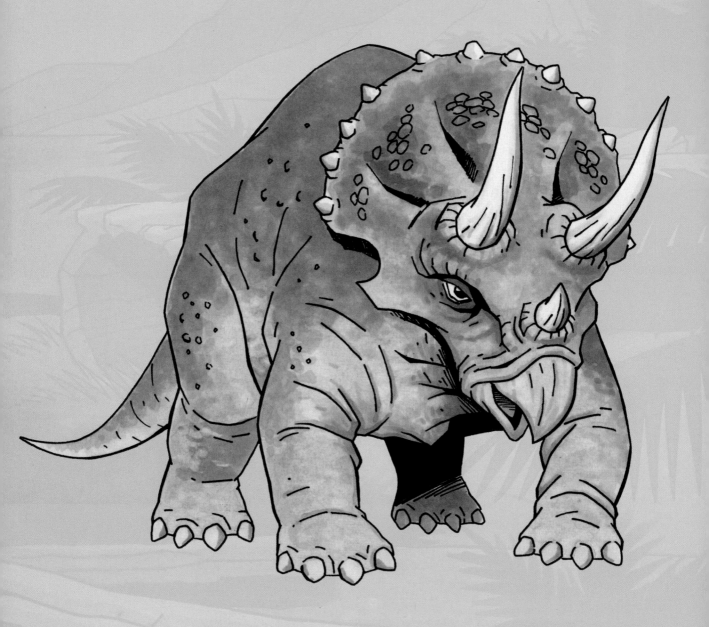

STEP 8

Color the Triceratops using a sand-colored base for its skin. Add a pale olive green along its back, tail, and face. Then, using a mid-gray, add patchy shading to its legs and underbelly, around the eyes, and to the horns.

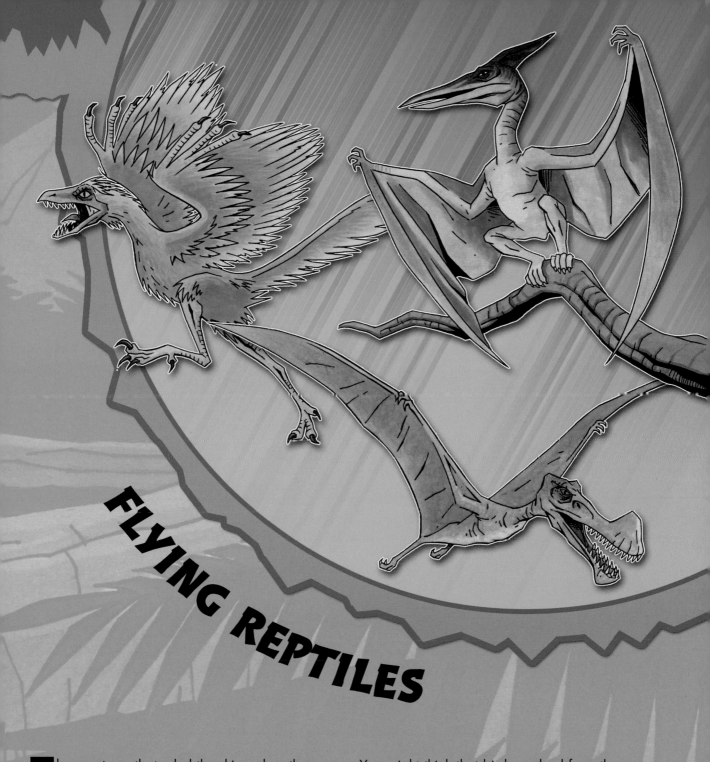

FLYING REPTILES

The creatures that ruled the skies when the dinosaurs lived were called pterosaurs. These fearsome flyers existed all over the world. They evolved from land-dwelling dinosaurs and are known as flying reptiles.

Some pterosaurs were tiny, about the size of a sparrow, but others were enormous and the size of a small aircraft. They were intelligent creatures with a good sense of smell, sight, and hearing, and they could fly for long distances.

You might think that birds evolved from the flying reptiles who had already taken to the skies, but this isn't the case. All the pterosaurs died out with the dinosaurs, and modern birds evolved from land-dwelling dinosaurs.

In this section you'll learn to draw two different pterosaurs as well as Archaeopteryx— the creature thought to be the first ever bird.

PTERANODON

DINO FACT FILE

Pteranodon was a terrifying flying reptile that was as tall as a human, with a massive pair of tough leathery wings. It was an intelligent creature with a big brain and excellent eyesight. Each different species had a unique bony head crest. It was a carnivore and hunted for fish, scooping them up from the water and swallowing them whole as it had no teeth. It also scavenged for dead animals.

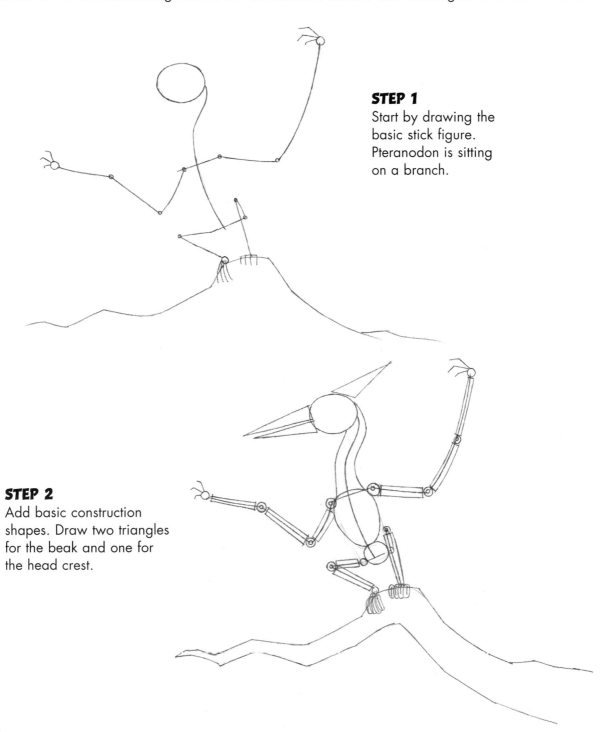

STEP 1
Start by drawing the basic stick figure. Pteranodon is sitting on a branch.

STEP 2
Add basic construction shapes. Draw two triangles for the beak and one for the head crest.

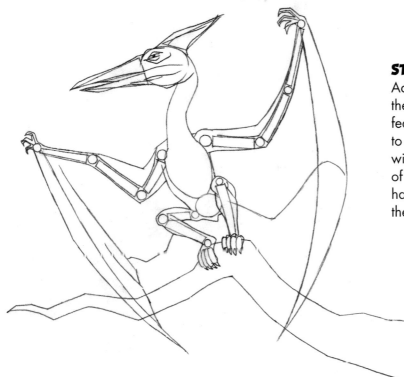

STEP 3

Add skin by drawing around the shapes. Draw the facial features and add definition to the head crest. Draw the wings. They're a continuation of the skin. Notice how they hang like sheets of cloth from the limbs. Add the claws.

STEP 4

Clean up your drawing by erasing your construction shapes. Add detail to the skin and to the tree branch.

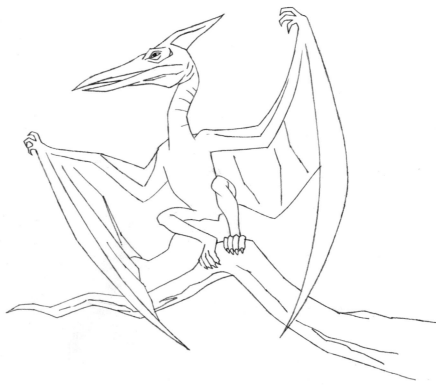

STEP 5

Now finalize your pencil drawing.
Add lots of detail to the skin, leathery
wings, and the branch. Add shading
to give your drawing perspective.

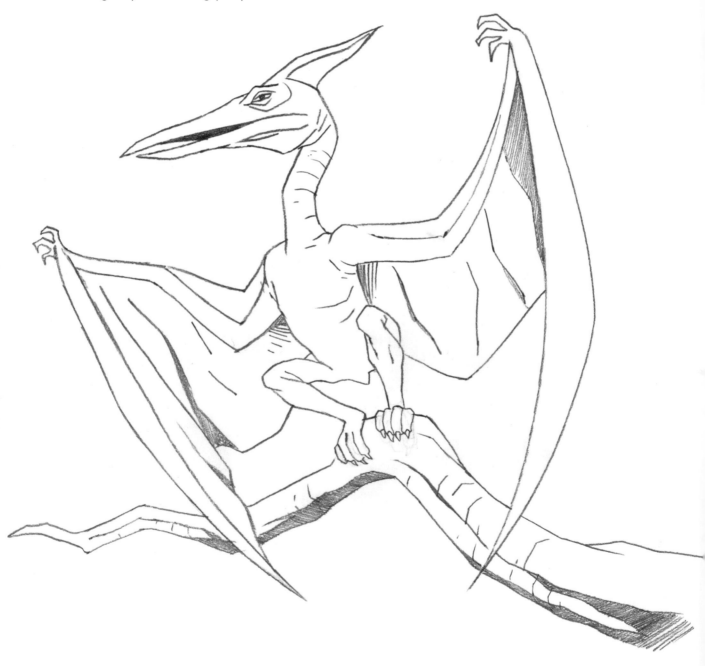

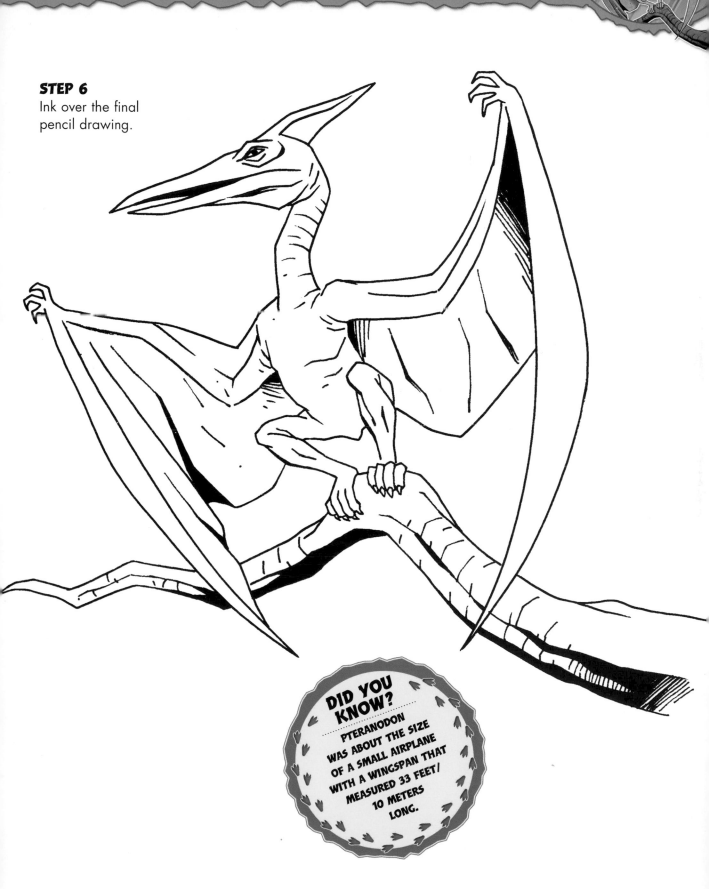

STEP 6
Ink over the final
pencil drawing.

DID YOU KNOW?
PTERANODON WAS ABOUT THE SIZE OF A SMALL AIRPLANE WITH A WINGSPAN THAT MEASURED 33 FEET/ 10 METERS LONG.

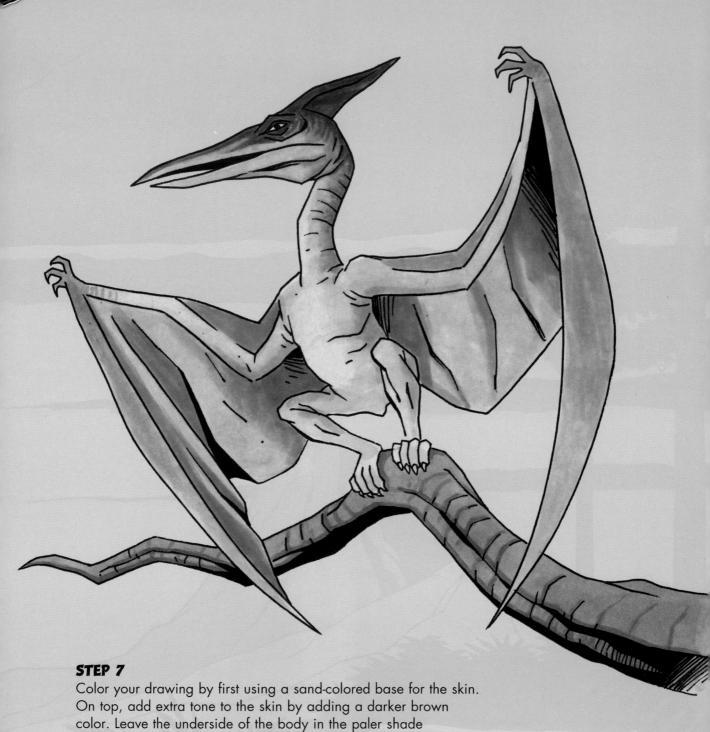

STEP 7

Color your drawing by first using a sand-colored base for the skin.
On top, add extra tone to the skin by adding a darker brown
color. Leave the underside of the body in the paler shade
Add further tone by applying a mid-gray to areas of its skin.
Also color the branch in this shade. Finally use a dark gray
to finish off the head and head crest.

TROPEOGNATHUS

DINO FACT FILE

Tropeognathus was slightly smaller than Pteranodon, but what it lacked in size, it made up for in razor-sharp teeth. It had a large beak with bony ridges on the top and bottom jaws. It used them to keep balanced as it skimmed along the surface of the water, catching fish to eat. These ridges prevented it from falling in and becoming an easy meal for hungry ocean predators.

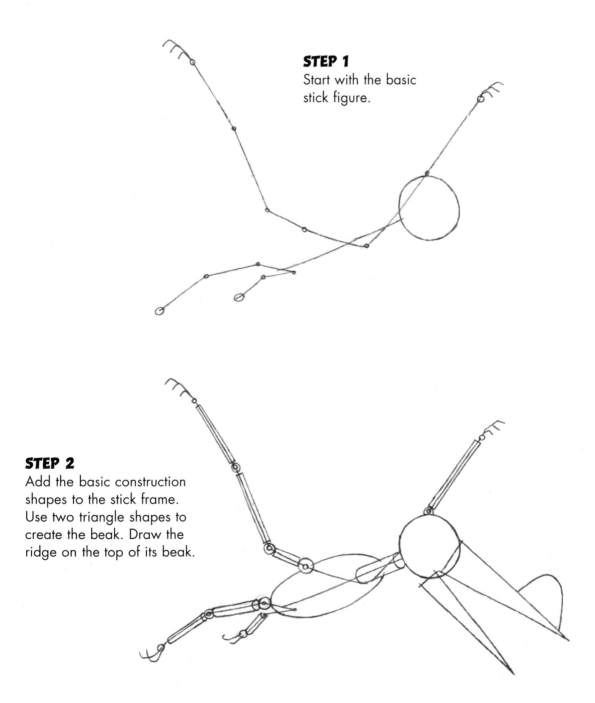

STEP 1
Start with the basic stick figure.

STEP 2
Add the basic construction shapes to the stick frame. Use two triangle shapes to create the beak. Draw the ridge on the top of its beak.

STEP 3

Now add the skin by drawing a line around the shapes. Loosely sketch out the wings. Most wings are wider at the point where they connect to the body and taper into a point at the end. Draw the eyes and facial features.

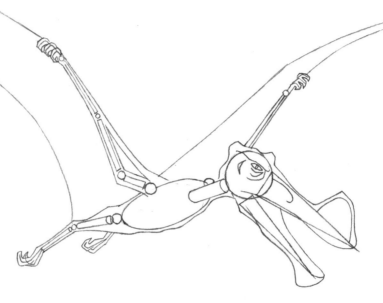

STEP 4

Remove your construction shapes. Add teeth and some detail to the skin and wings.

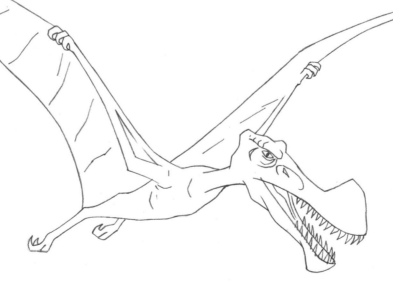

STEP 5

Finalize your pencil drawing, adding extra detail to the body, head, and wings.

STEP 6

Now ink over the pencil lines. Add shading to the mouth and eye areas.

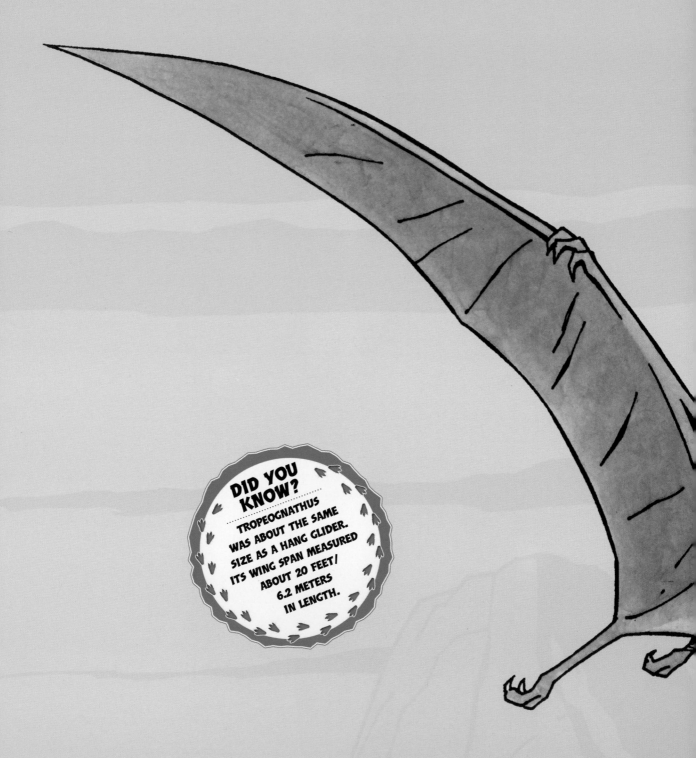

DID YOU KNOW?

TROPEOGNATHUS WAS ABOUT THE SAME SIZE AS A HANG GLIDER. ITS WING SPAN MEASURED ABOUT 20 FEET/ 6.2 METERS IN LENGTH.

STEP 7

Color the drawing starting with a pale sand color for the base. Go over the top of this with pale gray, leaving areas of its belly in the sand color. Apply sky blue over the gray which will make it look like pale gasoline blue. Finish off the beak in yellow, the tongue in pink and the eye in red.

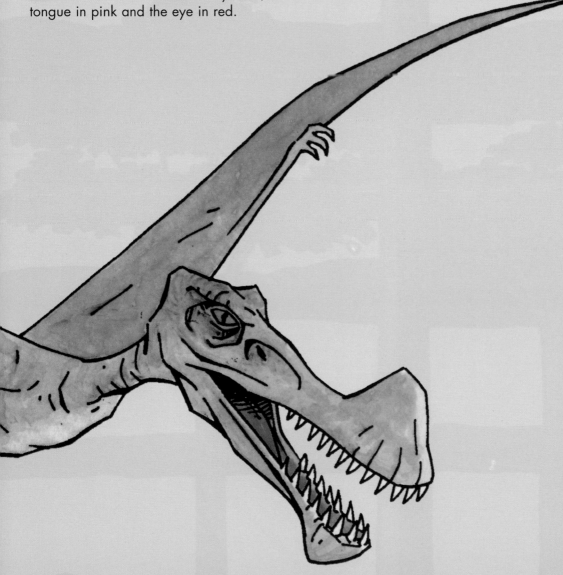

ARCHAEOPTERYX

DINO FACT FILE

This small, fascinating creature provides the evolutionary link between dinosaurs and modern-day birds. Archaeopteryx had birdlike features such as its all-over feathers, lightweight body, and large brain. Scientists now believe it was able to fly, not just glide. Its dinosaur features were its sharp teeth, the claws on its wings, and its long bony tail. It was about the size of a crow and ate meat.

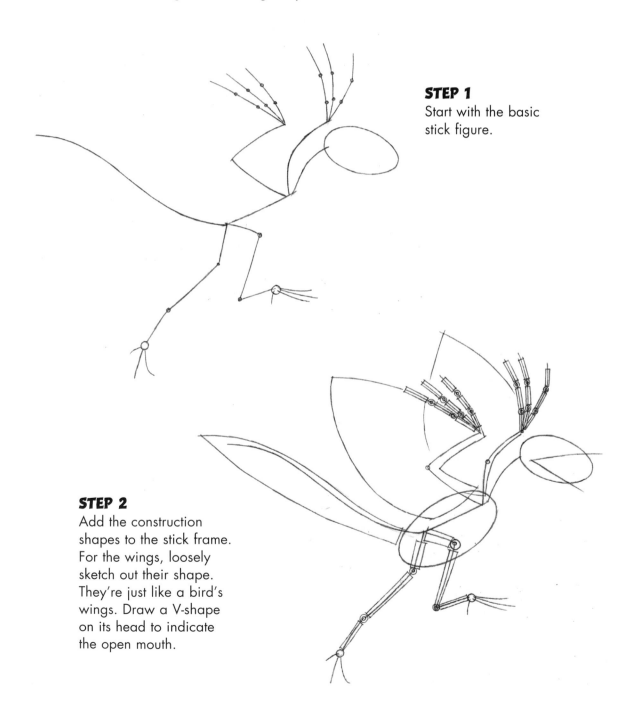

STEP 1

Start with the basic stick figure.

STEP 2

Add the construction shapes to the stick frame. For the wings, loosely sketch out their shape. They're just like a bird's wings. Draw a V-shape on its head to indicate the open mouth.

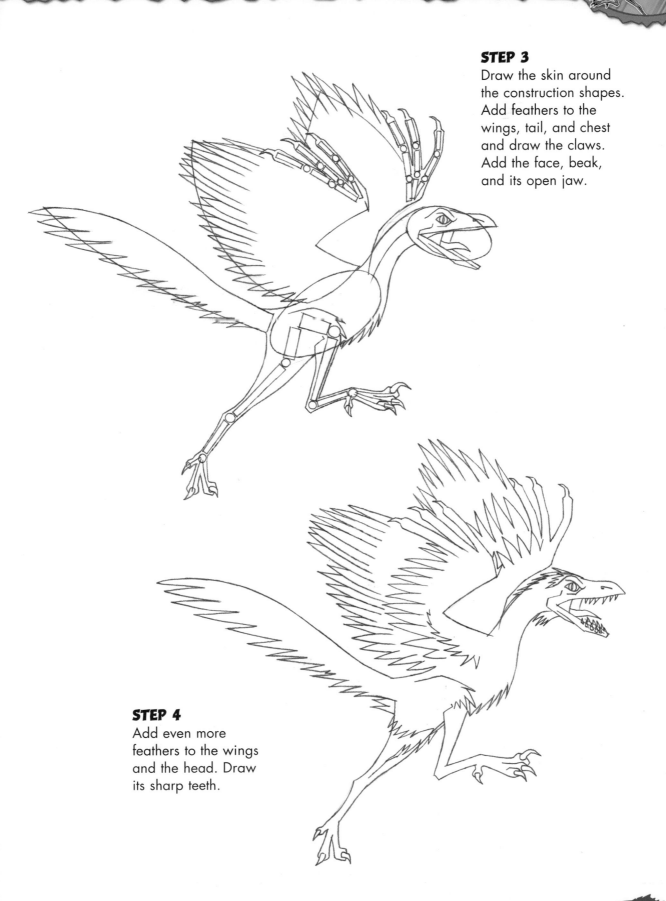

STEP 3
Draw the skin around the construction shapes. Add feathers to the wings, tail, and chest and draw the claws. Add the face, beak, and its open jaw.

STEP 4
Add even more feathers to the wings and the head. Draw its sharp teeth.

97

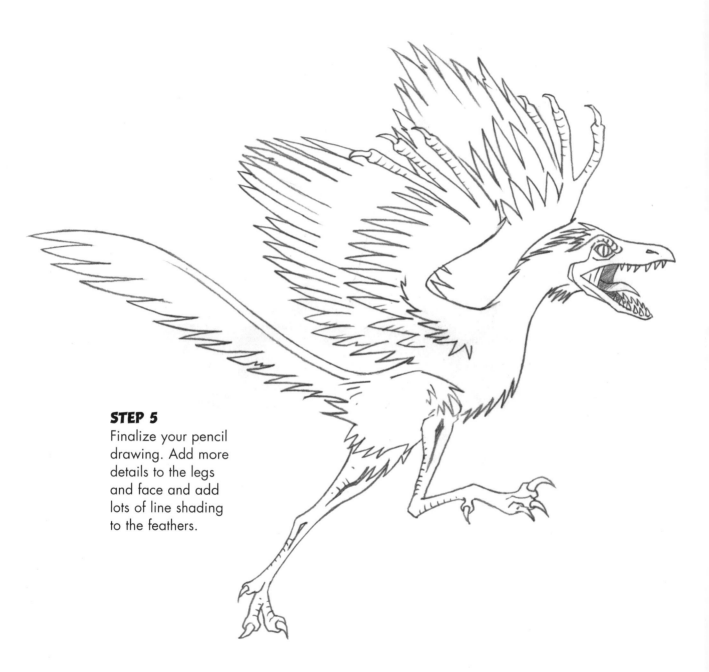

STEP 5
Finalize your pencil
drawing. Add more
details to the legs
and face and add
lots of line shading
to the feathers.

STEP 6
Ink over the finished
pencil drawing.

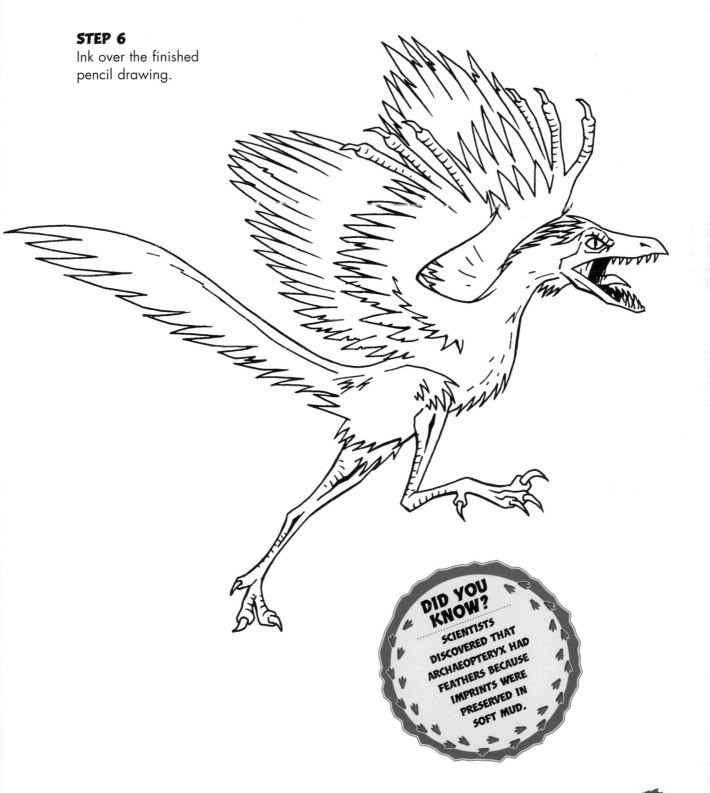

DID YOU KNOW?
...........
SCIENTISTS
DISCOVERED THAT
ARCHAEOPTERYX HAD
FEATHERS BECAUSE
IMPRINTS WERE
PRESERVED IN
SOFT MUD.

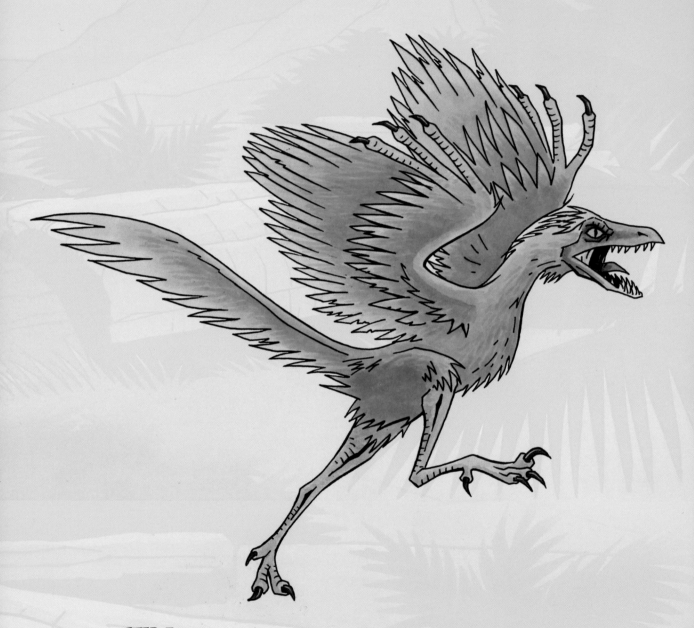

STEP 7

Color the Archaeopteryx starting with a pale yellow for the base of its feathers. Apply lime green over the top, leaving the tips of the feathers yellow. Now add a grass green to the darker areas to create contrast within the feathers. Use sandy colors for the legs and beak and add more yellow to finish the beak and eye.

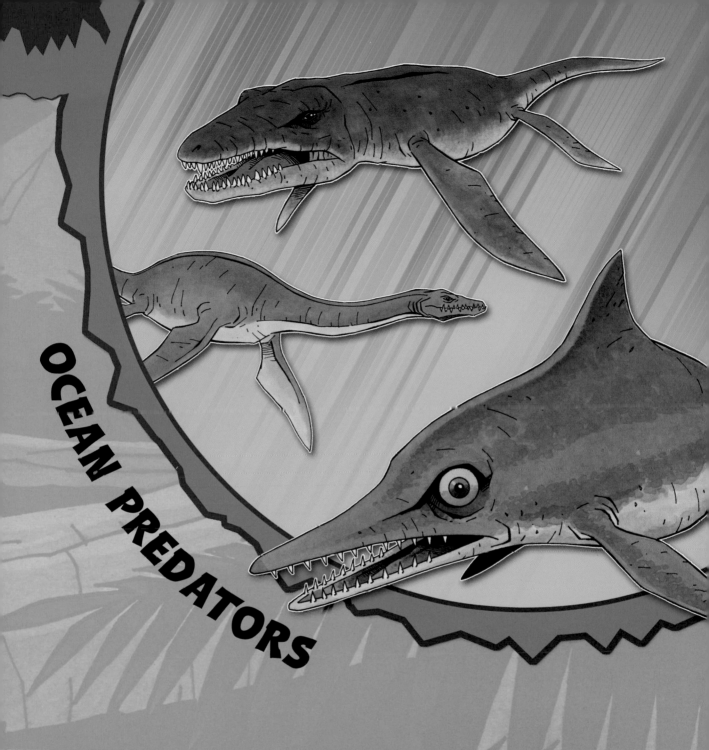

OCEAN PREDATORS

While dinosaurs dominated dry land, another group of prehistoric predators ruled the oceans. Huge marine reptiles were the kings of the water, and just like dinosaurs, they grew to extreme sizes.

These impressive sea monsters evolved from dinosaurs and adapted to life underwater, but they still had to come to the surface to breathe, and had nostrils on the top of their heads.

Ocean life at the time of the dinosaurs must have been a terrifying business and new species are being discovered all the time. Recently, an enormous marine reptile fossil was found in the Arctic, measuring 50 feet/15 meters long—that's the same as five cars all lined up! It's been nicknamed "The Monster."

In this chapter you'll learn to draw three deadly ocean predators.

ICHTHYOSAURUS

DINO FACT FILE

Ichthyosaurus was a streamlined dolphin-like marine reptile that could cut throught the water at incredible speeds—up to 25 miles/40 kilometers per hour. It lived underwater, but still needed to swim to the surface and breathe air. It had huge ear bones and eyes, giving it a keen sense of smell and excellent eyesight. It had lots of sharp teeth and long jaws for snapping up fish to eat.

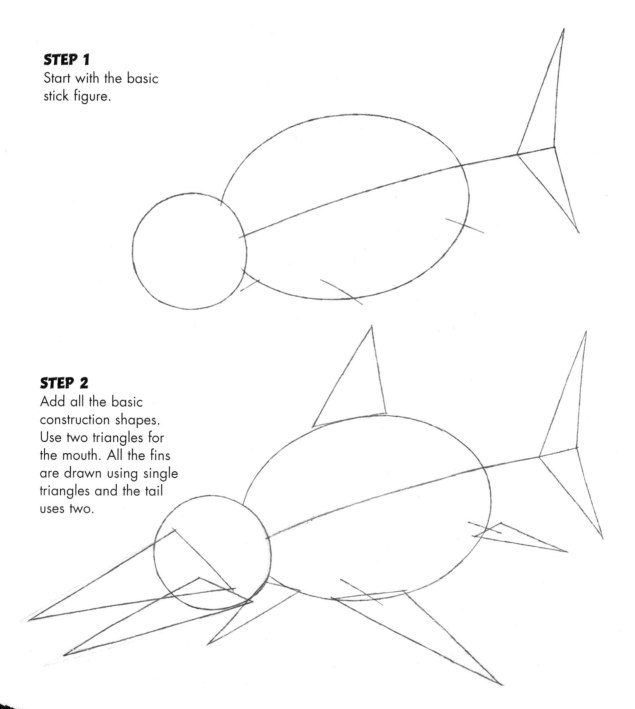

STEP 1
Start with the basic stick figure.

STEP 2
Add all the basic construction shapes. Use two triangles for the mouth. All the fins are drawn using single triangles and the tail uses two.

STEP 3

Go around the
construction shapes
to give the body its
proper form. Draw
the large eye.

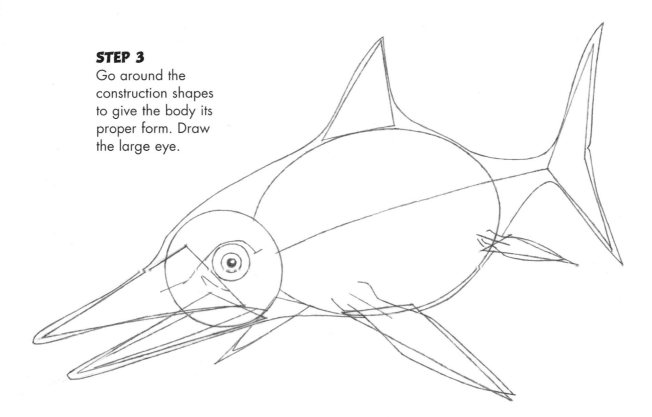

STEP 4

Remove all your construction
shapes so you have a clean
drawing. Draw in the teeth
and start adding some detail
to the skin.

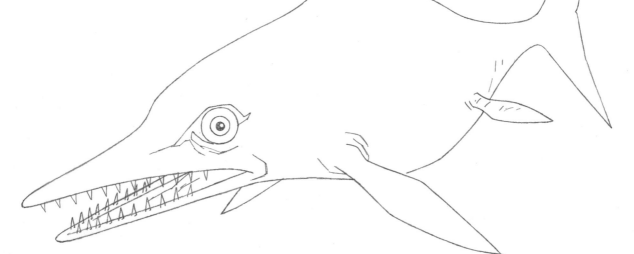

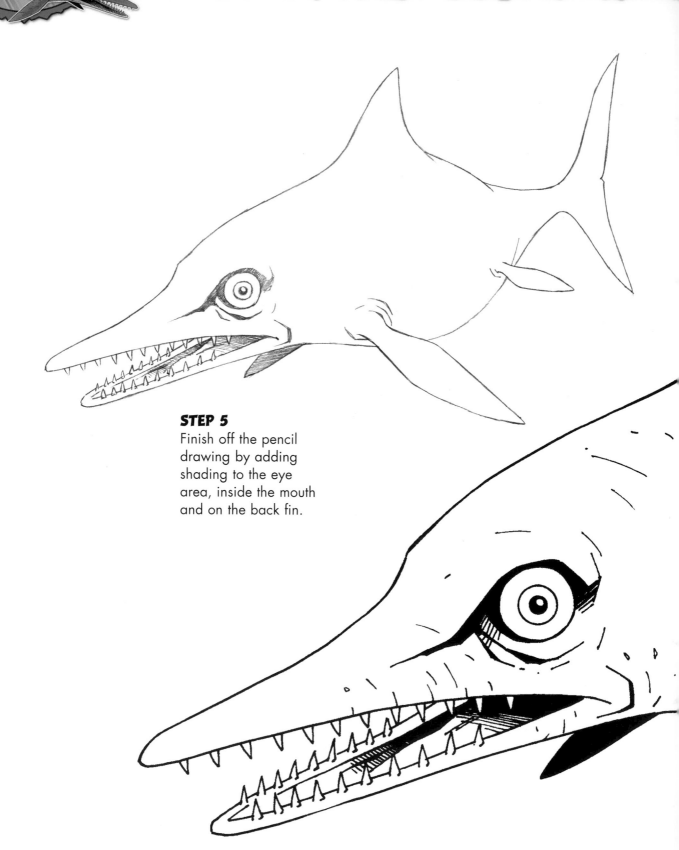

STEP 5
Finish off the pencil drawing by adding shading to the eye area, inside the mouth and on the back fin.

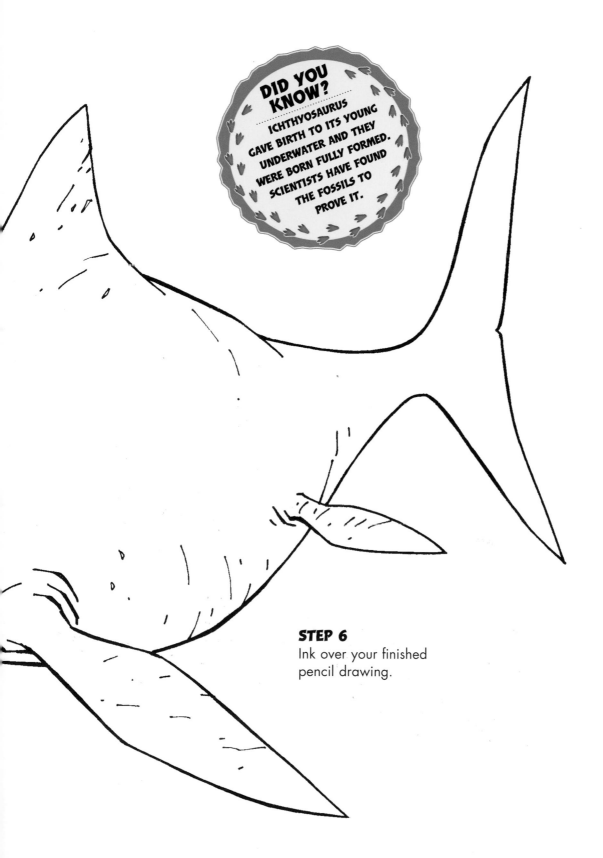

DID YOU KNOW?
ICHTHYOSAURUS GAVE BIRTH TO ITS YOUNG UNDERWATER AND THEY WERE BORN FULLY FORMED. SCIENTISTS HAVE FOUND THE FOSSILS TO PROVE IT.

STEP 6
Ink over your finished pencil drawing.

STEP 7

Now color your drawing. Apply a pale gray for the base color. Apply a very pale aqua over the gray, leaving its belly light gray. Over the aqua color add some sky blue. Then darken areas of the skin with a mid-blue, leaving areas of the lighter color showing through. Finish off by giving Ichthyosaurus a yellow eye.

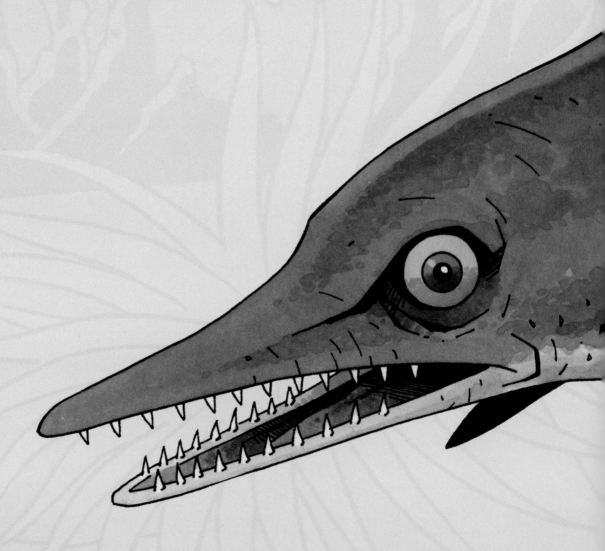

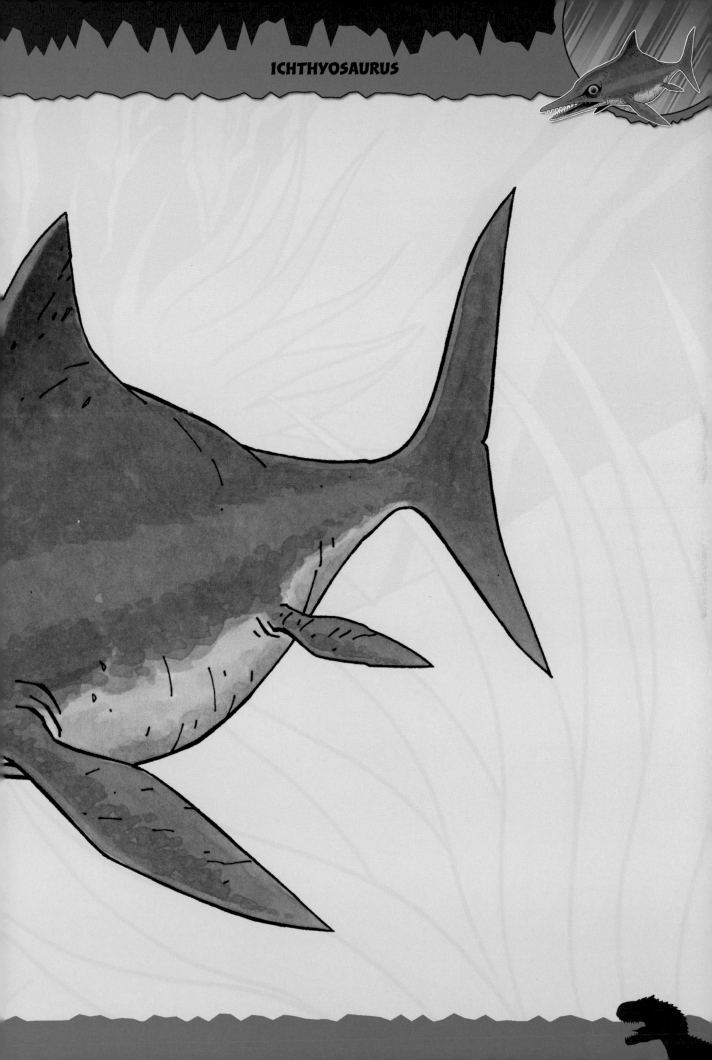

LIOPLEURODON

DINO FACT FILE

Liopleurodon was a gigantic ocean predator measuring 35 feet/10 meters in length (although some paleontologists think it was much bigger). It was a powerful swimmer with big strong jaws filled with rows of razor-sharp teeth, each one as long as a sword. It sat at the top of the food chain and had no predators so it cruised the depths with its mouth open, ready to catch its prey.

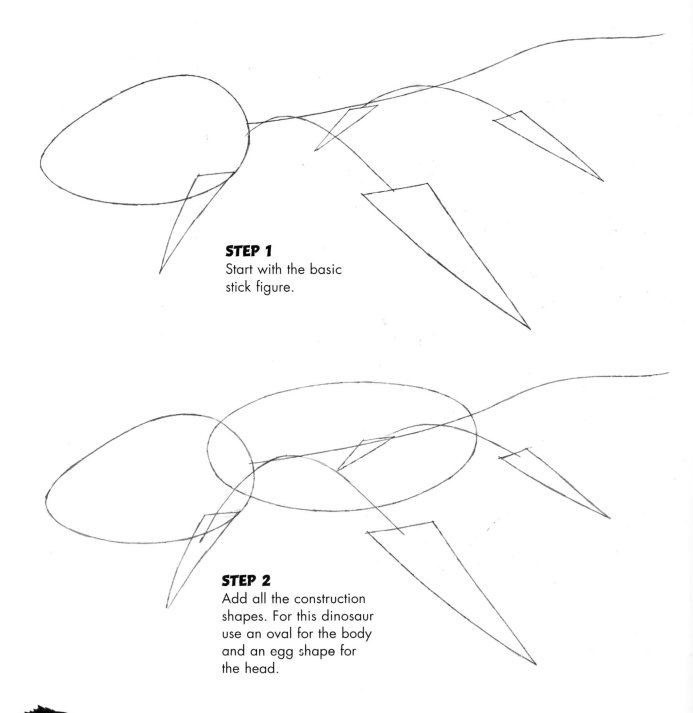

STEP 1

Start with the basic
stick figure.

STEP 2

Add all the construction
shapes. For this dinosaur
use an oval for the body
and an egg shape for
the head.

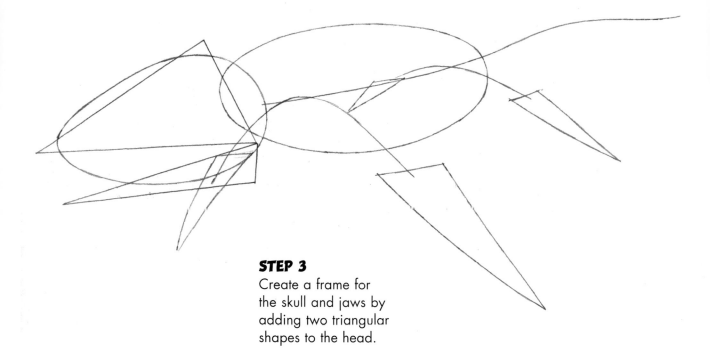

STEP 3
Create a frame for
the skull and jaws by
adding two triangular
shapes to the head.

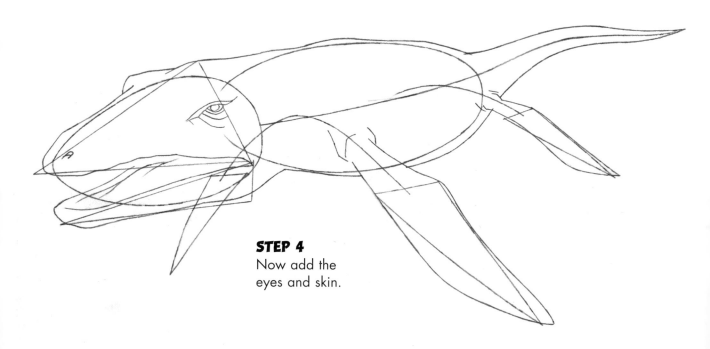

STEP 4
Now add the
eyes and skin.

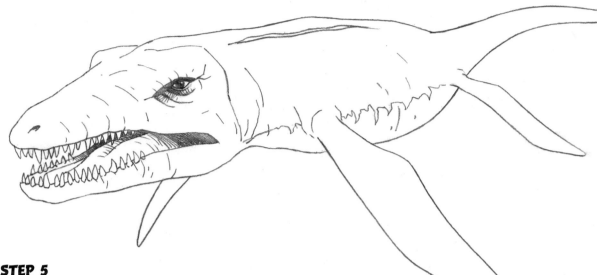

STEP 5
Finish off your pencil drawing.
Add shading around the eye and
inside the mouth, and develop
more details on the skin.

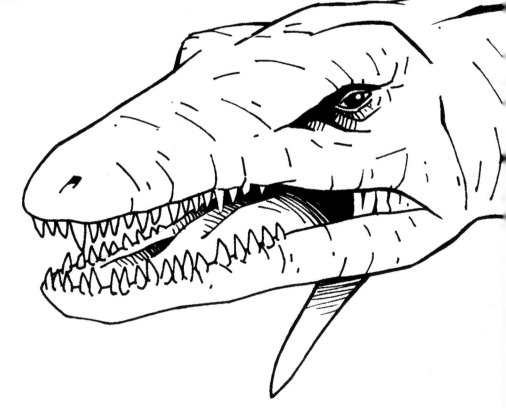

DID YOU KNOW?

LIOPLEURODON WAS ONE OF THE BIGGEST MARINE REPTILES THAT HAS EVER EXISTED. ITS TEETH WERE SO STRONG THEY COULD BITE THROUGH GRANITE.

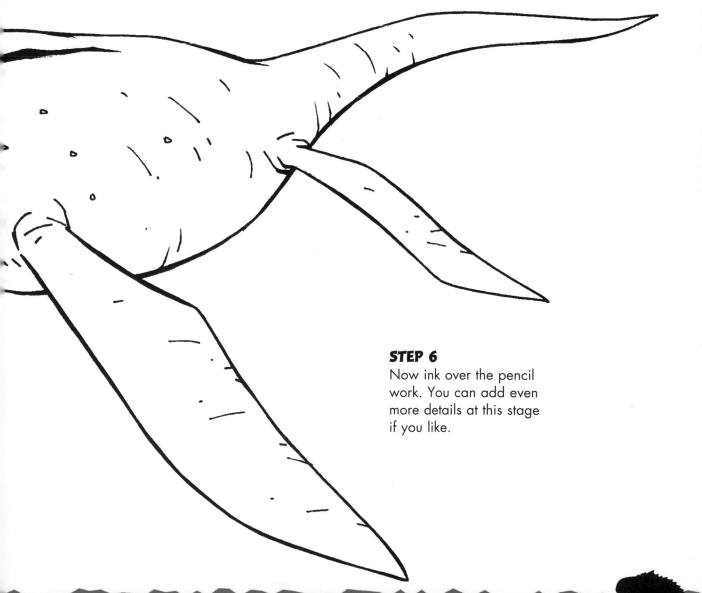

STEP 6
Now ink over the pencil work. You can add even more details at this stage if you like.

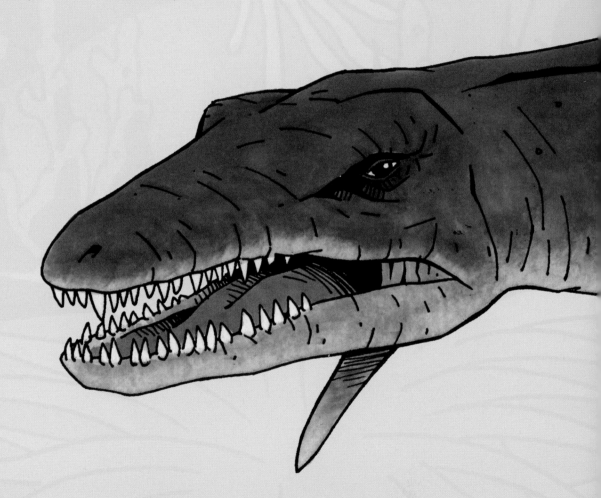

STEP 7

To color Liopleurodon, use pale gray for the base color. Apply mid-gray along its back and tail, and along the tops of its fins. Add sky blue on top of this to finish the body. Use pink with gray shading for the tongue.

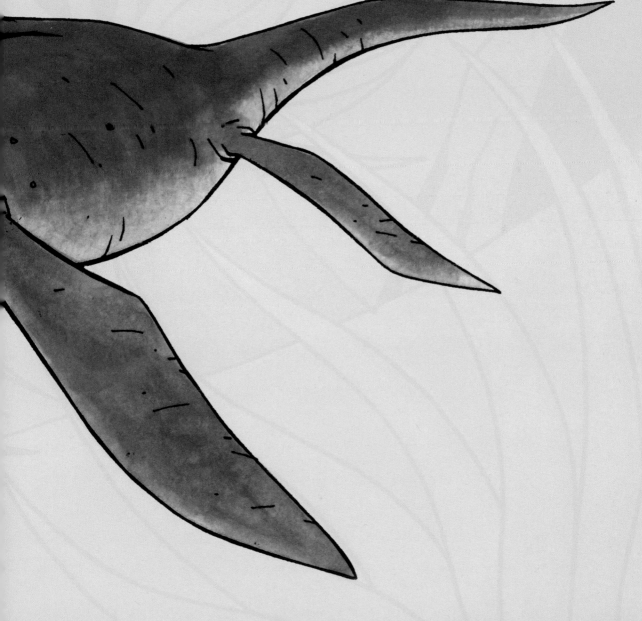

PLESIOSAURUS

DINO FACT FILE

Plesiosaurus was the first plesiosaur to be discovered. Plesiosaurs were a group of marine reptiles with long necks, small heads, and paddle-like flippers. They hatched from eggs buried on sandy shores, as turtles do, but they had crocodile-like teeth and jaws. Specimens have been found with stones in the belly, which they swallowed to help digest food, or to weigh them down for diving.

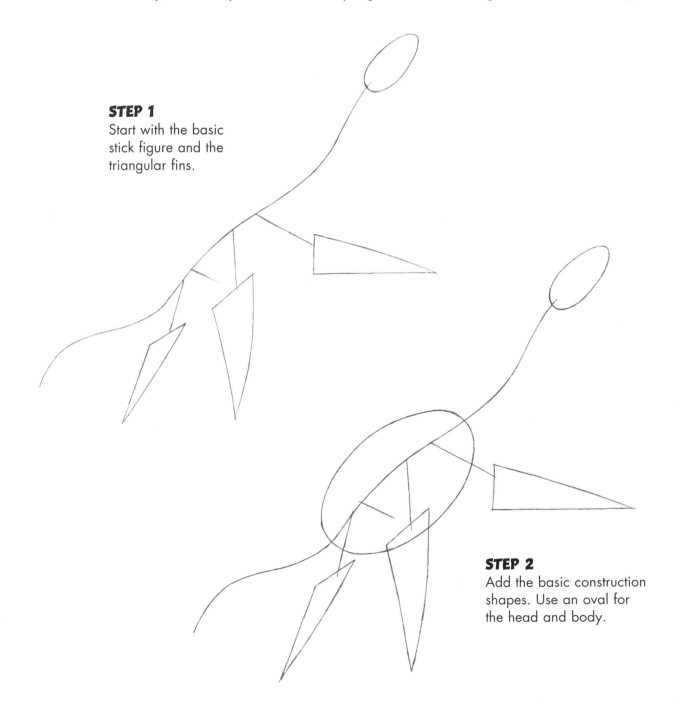

STEP 1
Start with the basic stick figure and the triangular fins.

STEP 2
Add the basic construction shapes. Use an oval for the head and body.

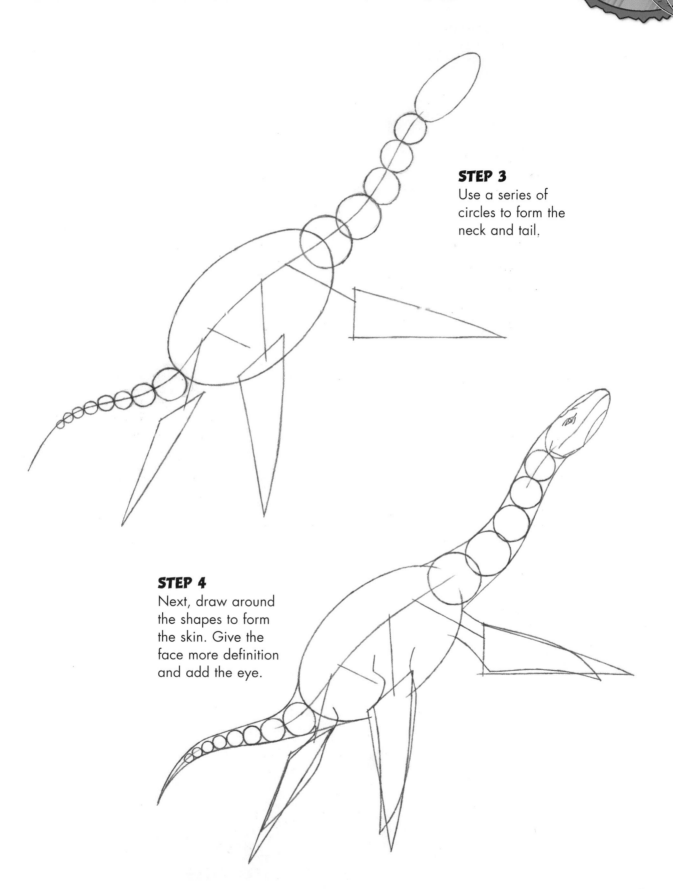

STEP 3
Use a series of circles to form the neck and tail,

STEP 4
Next, draw around the shapes to form the skin. Give the face more definition and add the eye.

STEP 5

Remove any unwanted lines and construction shapes and clean up your pencil drawing. Finalize it by adding creases and markings to the skin. Add the crocodile-like teeth and some shading.

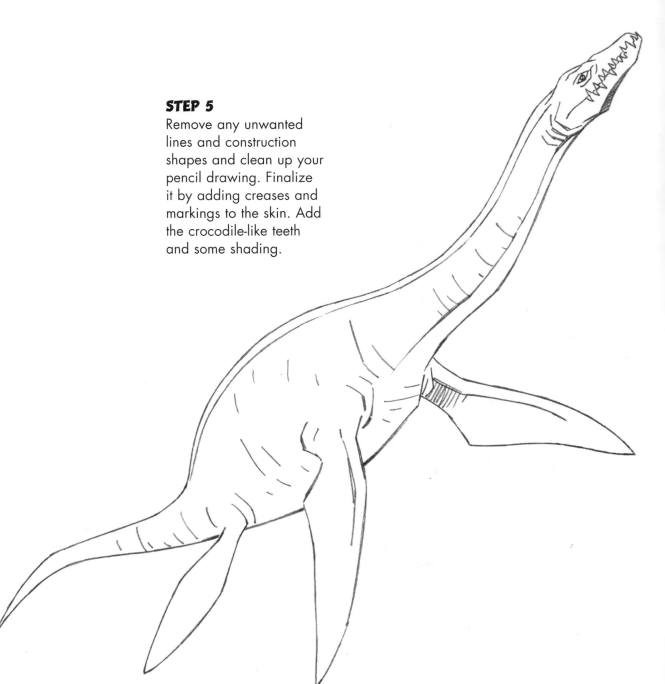

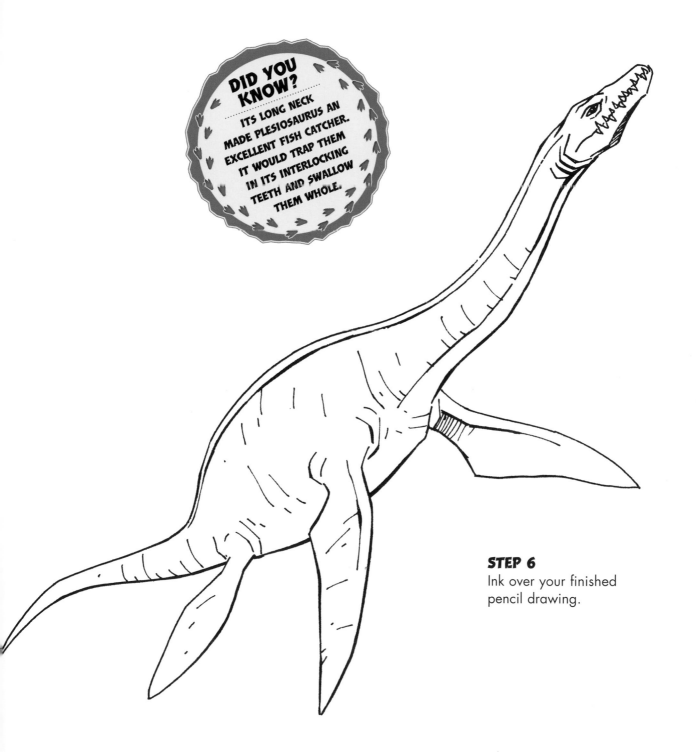

DID YOU KNOW?

ITS LONG NECK MADE PLESIOSAURUS AN EXCELLENT FISH CATCHER. IT WOULD TRAP THEM IN ITS INTERLOCKING TEETH AND SWALLOW THEM WHOLE.

STEP 6
Ink over your finished pencil drawing.

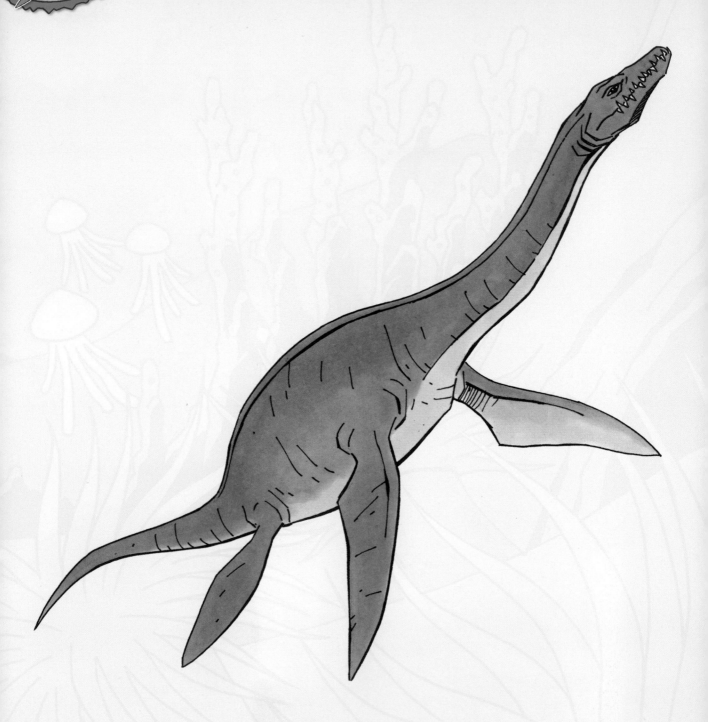

STEP 7

Finally, add color to your Plesiosaurus. Apply a pale gray for the base color. Next apply a very pale aqua over the gray, leaving its belly in the light gray. Over the aqua color add sky blue. Then darken areas of the skin with a mid-blue, leaving areas of the lighter color showing through.

LANDSCAPES AND SCENERY

Dinosaurs existed for more than 160 million years, and during their reign Earth's landscape changed dramatically.

Earth was once one huge landmass called Pangaea, that gradually broke apart to form the continents we have today. Temperatures were much hotter than they are today, so hot there was no polar ice. The conditions were perfect for dinosaurs to flourish.

Once you've mastered how to draw dinosaurs, it might be fun to draw some prehistoric landscapes for them to appear in. You could even create a huge picture with all of your favorite dinosaurs in it.

Here we'll show you how to draw three dramatic scenes: one on land, one in the air, and one underwater, each featuring one of the dinosaurs you've already drawn.

LANDSCAPES AND LAND DWELLERS

LANDSCAPE FEATURING GIGANOTOSAURUS

Giganotosaurus was around about 100 million years ago. This was the golden age of dinosaurs, before their mass extinction. Many incredible creatures had evolved and this diversity was also found in the plants, flowers, and landscapes on Earth. Giganotosaurus roamed the plains and valleys of Argentina, South America, where it would hunt giant plant eaters.

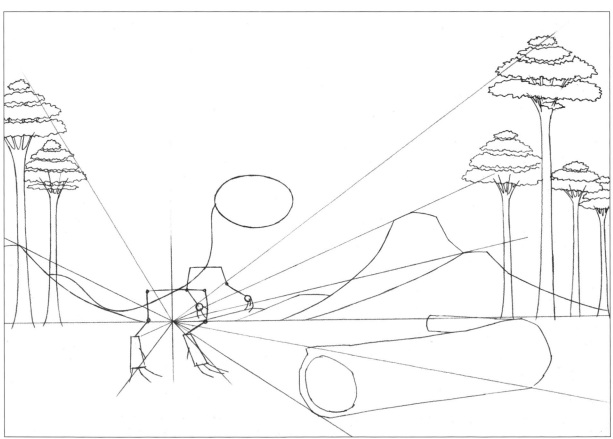

STEP 1 Draw the horizon line just below half way down the page. Sketch in some hills and trees. Draw the stick figure for a Giganotosaurus. Add a fallen tree trunk in the foreground and some leaves on the trees in the background.

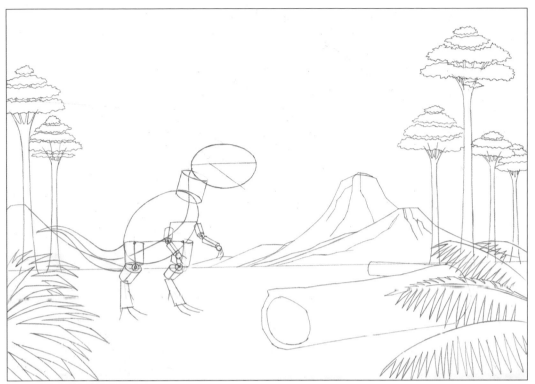

STEP 2 Construct the Giganotosaurus (see pages 52–7 for the step-by-step guide). Next, draw some fernlike plants in the foreground and develop the mountain rock.

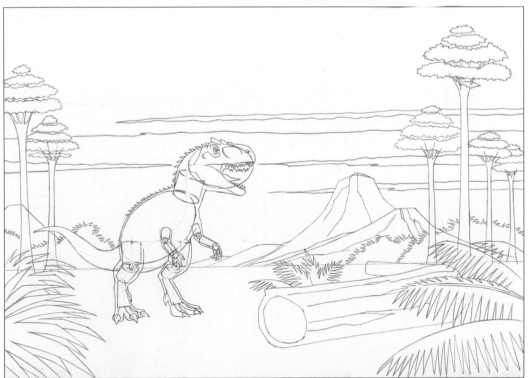

STEP 3 Draw some smaller bushes in the background, in front of the mountains on the horizon line. Add clouds in the sky. Add skin and teeth to the Giganotosaurus.

STEP 4 Complete the pencil drawing by adding shading to create areas of black and all your final details to the dinosaur and scenery.

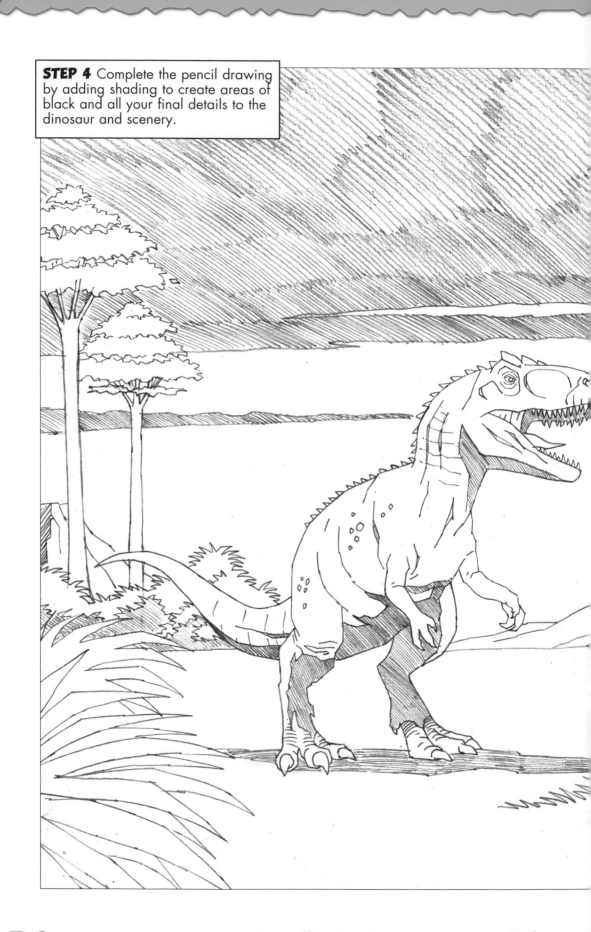

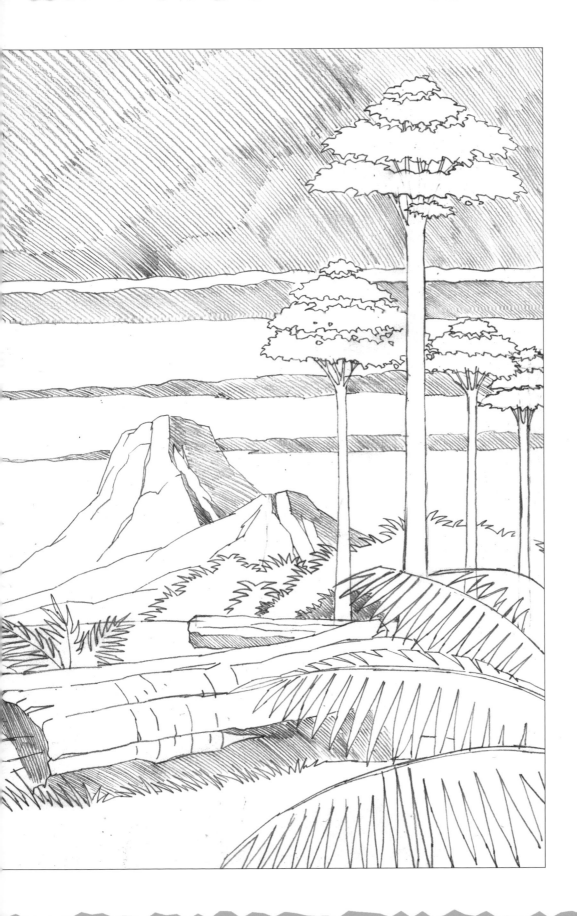

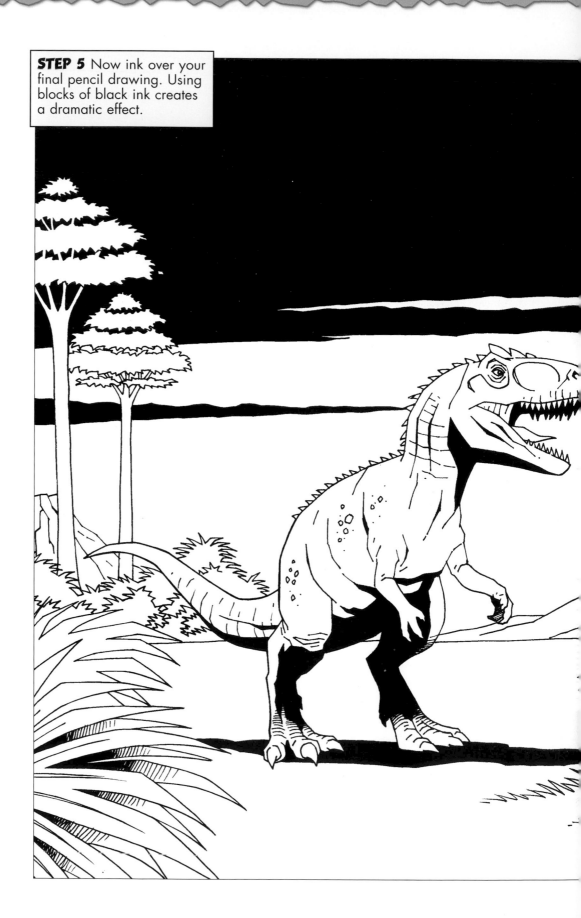

STEP 5 Now ink over your final pencil drawing. Using blocks of black ink creates a dramatic effect.

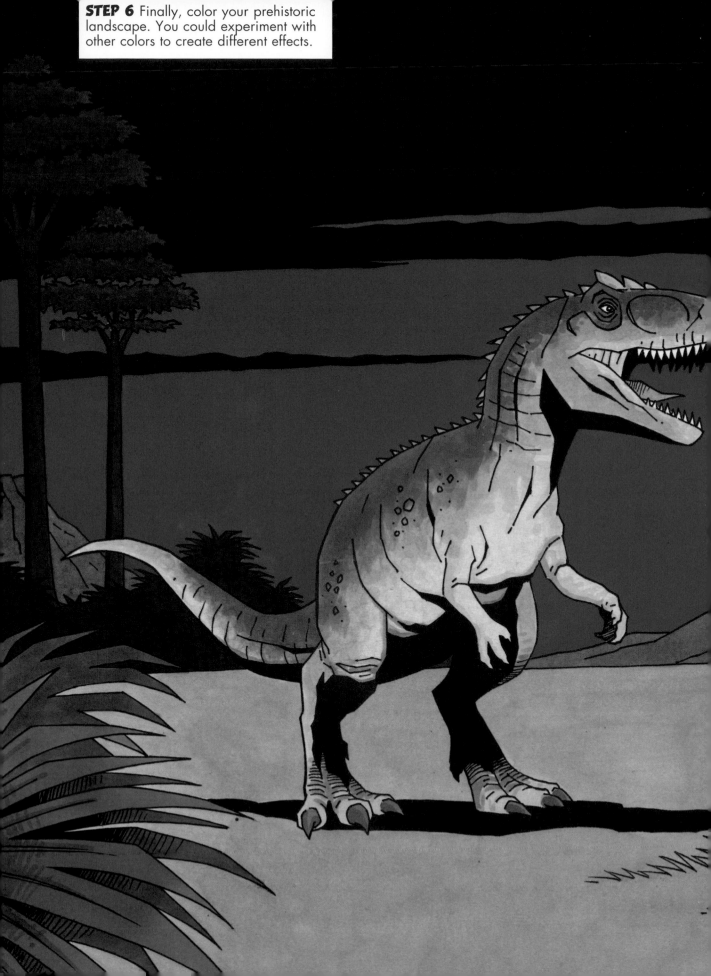

STEP 6 Finally, color your prehistoric landscape. You could experiment with other colors to create different effects.

SKY SCENE AND FLYING CREATURES

SKY SCENE FEATURING TROPEOGNATHUS

Tropeognathus could be seen in the sky about 120 million years ago. The Earth was teeming with different species not only on land, but also in the air and the oceans. Flying reptiles were growing to huge sizes and the sea was at its richest. Where better to draw this incredible predator than gliding over the ocean, ready to scoop up some fish in its beak?

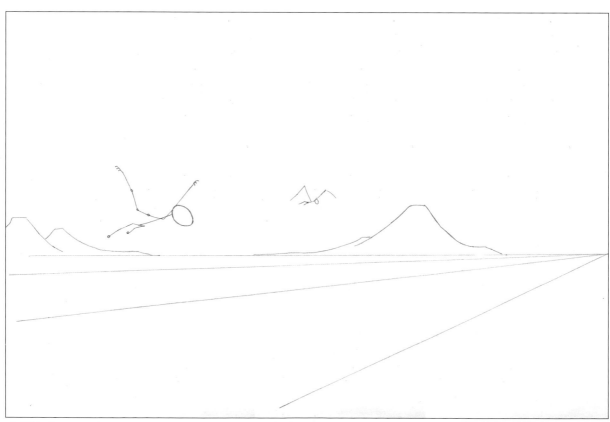

STEP 1 Draw the horizon line one third up the page. The perspective lines go farther than the finished drawing does, but it's still useful to draw them in to give you a sense of distance. On the horizon line, draw two sets of mountains. The one on the right will be a volcano. Draw two stick figures which will form the Tropeognathus (see pages 91–5 for the step-by-step guide).

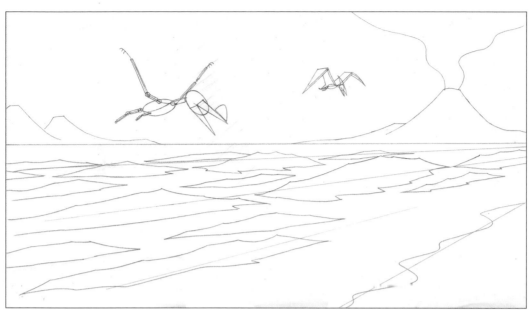

STEP 2 Using the perspective lines as a grid, draw wave shapes going off into the distance. Think of waves like mini mountains to get the shape. Draw swirling lines for the smoke coming from the volcano. Add the construction shapes to Tropeognathus.

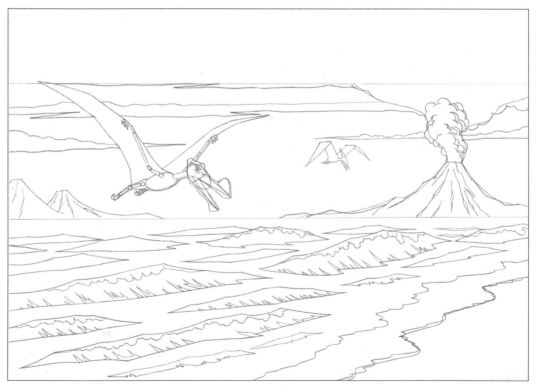

STEP 3 Add crests to the waves and detail of movement at the bottom of the waves. Give some definition to the volcano to make it look rocky and finish the smoke. Add some clouds in the sky. Draw the skin, wings, and face of the Tropeognathus.

STEP 4 Complete your final pencil drawing by adding all your shading, which will really take the drawing to the next level. Remove any unwanted lines and add your final details.

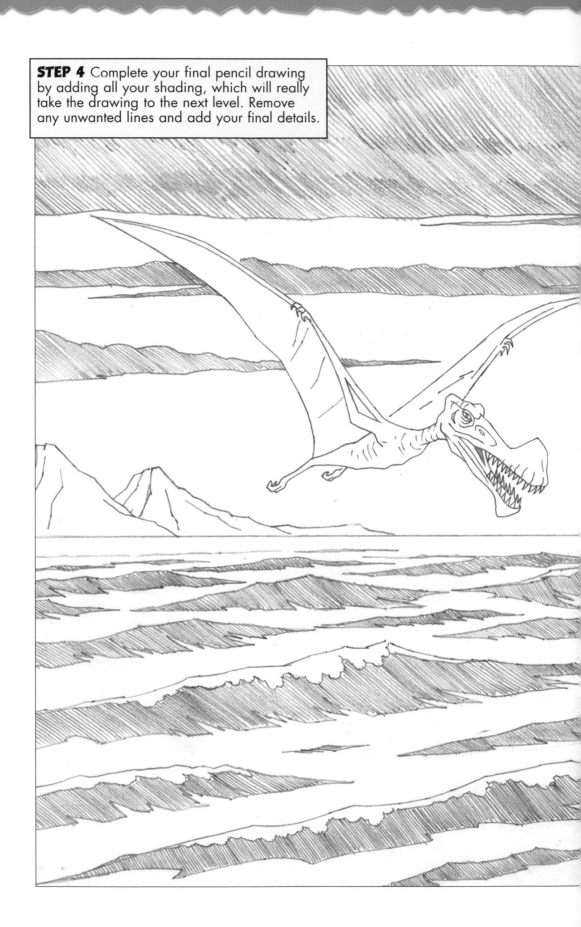

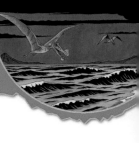

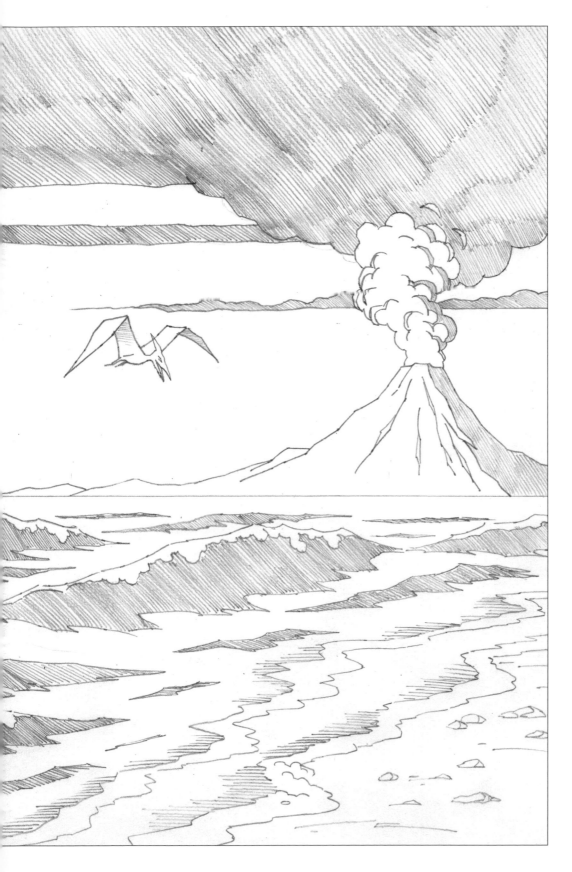

STEP 5 Ink over your finished pencil drawing. By perfecting the shading on the waves you can make them look very realistic.

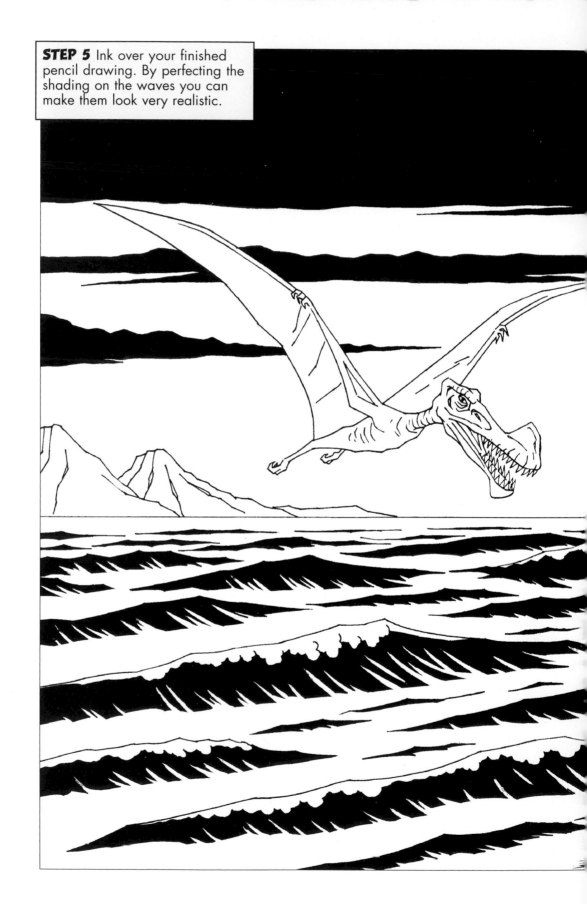

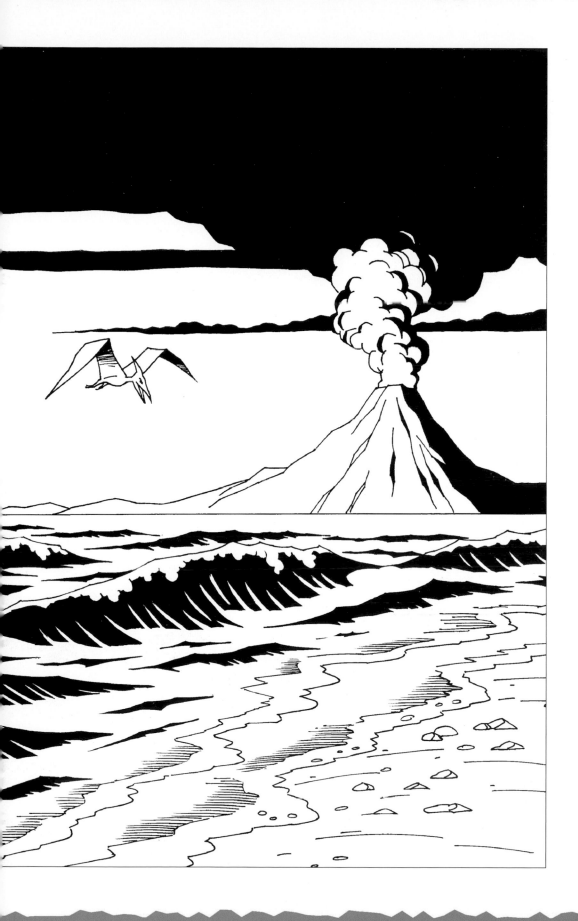

STEP 6 Color your drawing.
Different shades of blue will
really bring this seascape to life.

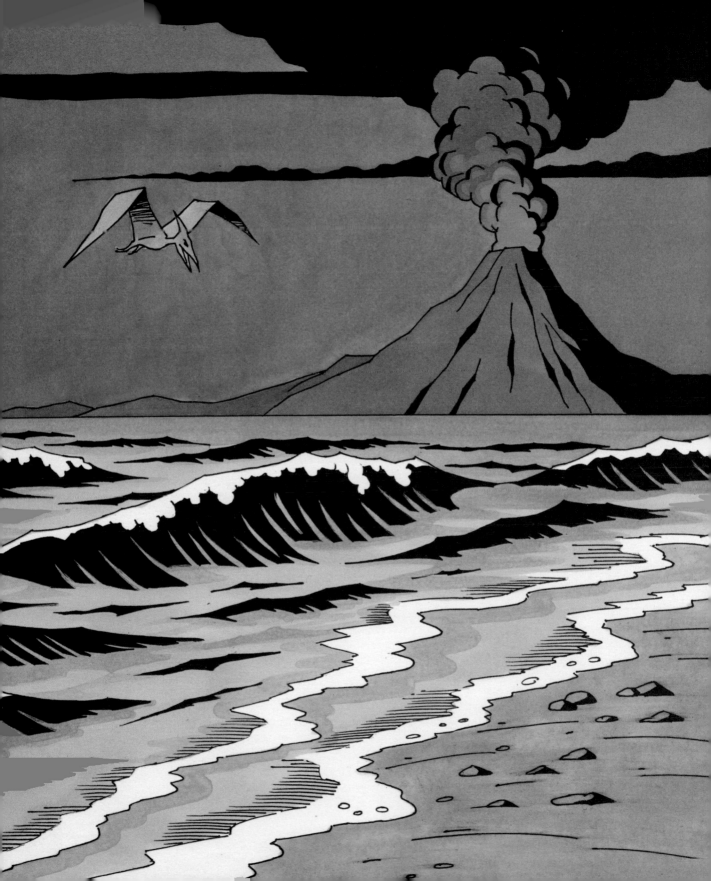

OCEAN SCENE

OCEAN SCENE FEATURING PLESIOSAURUS

Plesiosaurus survived the mini mass extinction that occurred at the end of the Jurassic period, which killed many marine creatures. It spent all of its time underwater and survived until all dinosaurs died out 65 million years ago. The reason for its success was partly its long neck, which allowed it to trawl along the seabed, gulping up shellfish as well as hunting larger, swimming fish.

STEP 1 Draw a horizon line a quarter from the bottom of the page. On the right, draw a series of curves. Make them bigger and wider in the foreground and smaller and less steep as they go into the distance. Now plot the position of the Plesiosaurus roughly in the center of the page. Draw the basic stick figure (see pages 114–118 for the step-by-step guide).

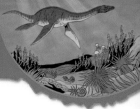

STEP 2 Now add some more detail. Draw lines in the rock on either side and some groups of coral. Add a series of circles for the neck and tail of the Plesiosaurus.

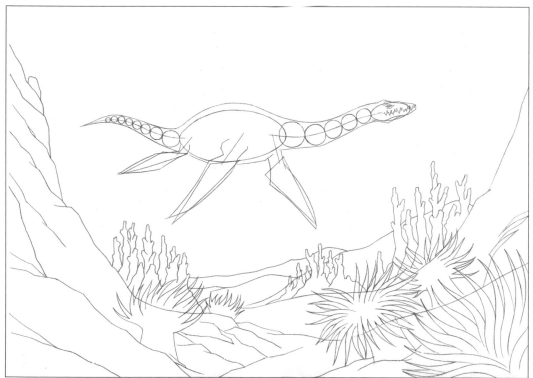

STEP 3 Add some plant life to the seabed. Draw sea anemones in the foreground, varying the sizes to create a sense of depth. Add more detail to the Plesiosaurus.

STEP 4 To finish your pencil drawing, erase any unwanted lines and finalize all the details. Add some shellfish and jellyfish to complete the scene.

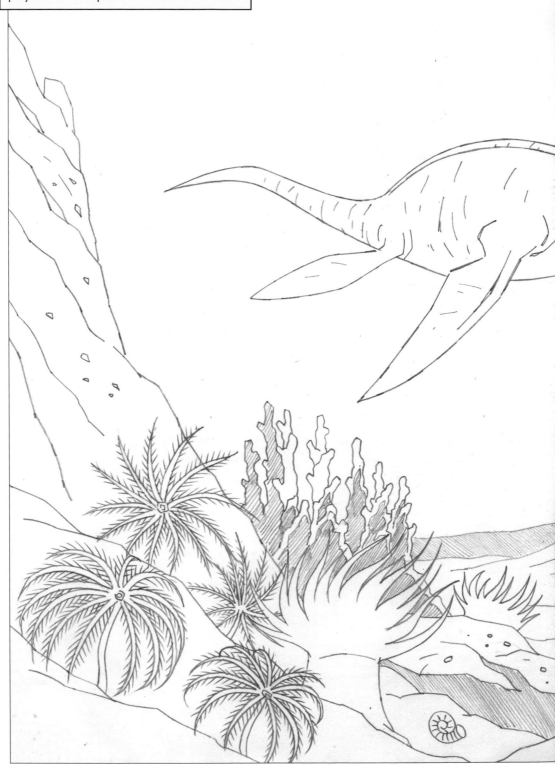

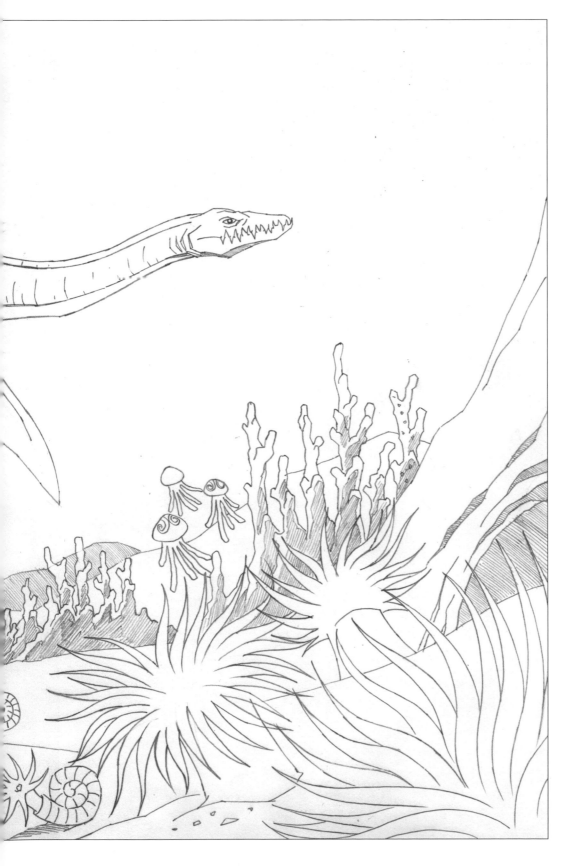

STEP 5 Ink over your final pencil drawing. Adding areas of solid black shading will create an increased sense of depth and atmosphere.

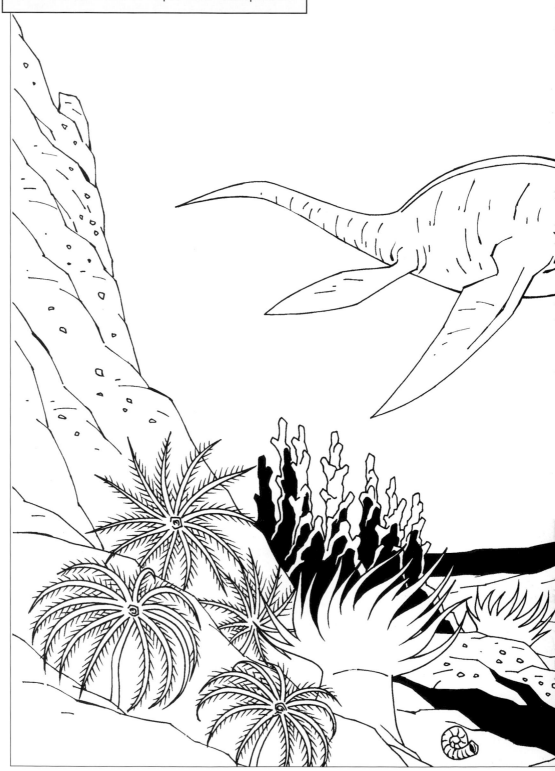

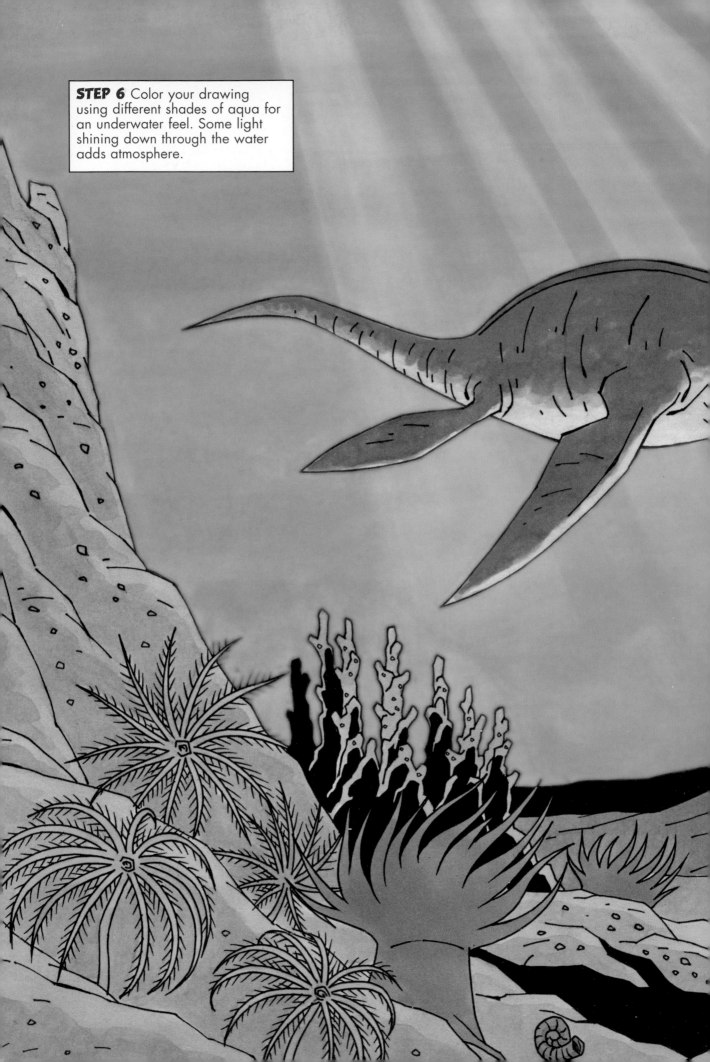

STEP 6 Color your drawing using different shades of aqua for an underwater feel. Some light shining down through the water adds atmosphere.

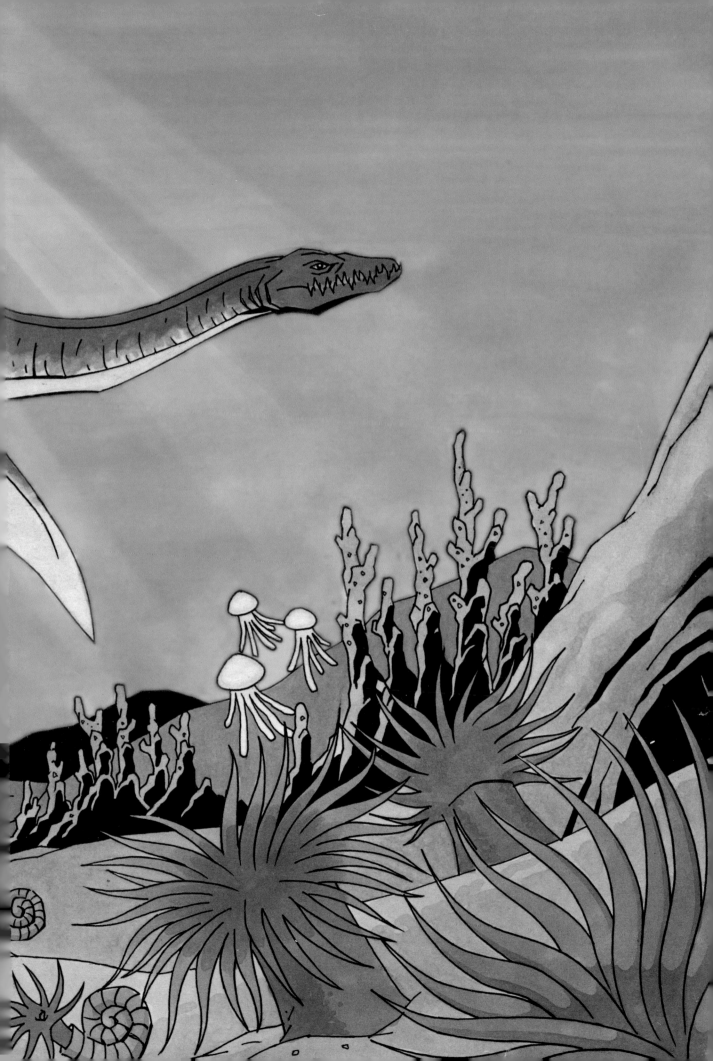